"I have touched with a sense of art some people—they felt the love and the life. Can you offer me anything to compare to that joy for an artist?"

Mary Cassatt
American Painter and Printmaker

LOVELY

LADIES OF ANIMATION

THE ART OF
Lorelay Bové, Mingjue Helen Chen, Claire Keane
Lisa Keene, Brittney Lee, & Victoria Ying

EXTRACURRICULAR
ACTIVITES

designstudio|PRESS

Copy Editors: Jonathan Ying and Jessica Hoffmann | **Graphic Design:** Michael Yamada

Published by

Design Studio Press
Address: 8577 Higuera Street, Culver City, CA 90232 | **Website:** www.designstudiopress.com | **E-mail:** info@designstudiopress.com

in association with

Extracurricular Activities
Website: www.eca-la.com | **E-mail:** say@eca-la.com

Printed in China | First Edition, May 2014

10 9 8 7 6 5 4 3 2

Library of Congress Control Number: 2014930173 | **Hardcover ISBN-13:** 9781624650130

TABLE OF CONTENTS

WALT DISNEY ANIMATION
The Roy O. Disney Building
Burbank, CA

FOREWORD

No discussion of the history of the Walt Disney Studios is complete without mention of one of its most celebrated artists: Mary Blair. Her work was unique, incredibly appealing, and deeply influential on Walt Disney and the many artists at the studio.

Like Mary Blair, these women of animation are energizing their field. Lorelay Bové, Mingjue Helen Chen, Claire Keane, Lisa Keene, Brittney Lee, and Victoria Ying are responsible for some of the most creative and appealing work that I've ever seen. Appeal is not taught in any school; it's something you have to have an intuitive sense for. The talent and skill on display in the work these artists have created for Disney has been a daily inspiration, and it's a true pleasure to get to see the work they devote themselves to in their personal time. I always say that you are what you direct, you are what you animate, you are what you paint or draw. In these pages you see six incredible artists. We are lucky to work alongside them.

John Lasseter
Chief Creative Officer
Walt Disney and Pixar Animation Studios

INTRODUCTION

Six talented women—each with a unique background, style, and personality—have come together. Having found a creative garden to work in, they have influenced and encouraged one another by a common passion for storytelling through their art. And as a result, their designs have shaped all of the animated features that have come from Disney Studios over the last decade. The wonderful art presented in this book is a window into their personal work, revealing what inspires each of them.

The genesis of this anthology springs from an invitation to exhibit their art in Paris at the Arludik Gallery by Jean-Jacques and Diane Launier. Situated on the Île St. Louis, the gallery is a gathering place for all who appreciate the tremendous skill and talent of the artists behind the films, children's books, and graphic arts of today.

I can't help but smile and feel lighter when I see their work. There is something wonderfully refreshing about art that is created with such pure joy . . . it is truly lovely.

Glen Keane
Animator

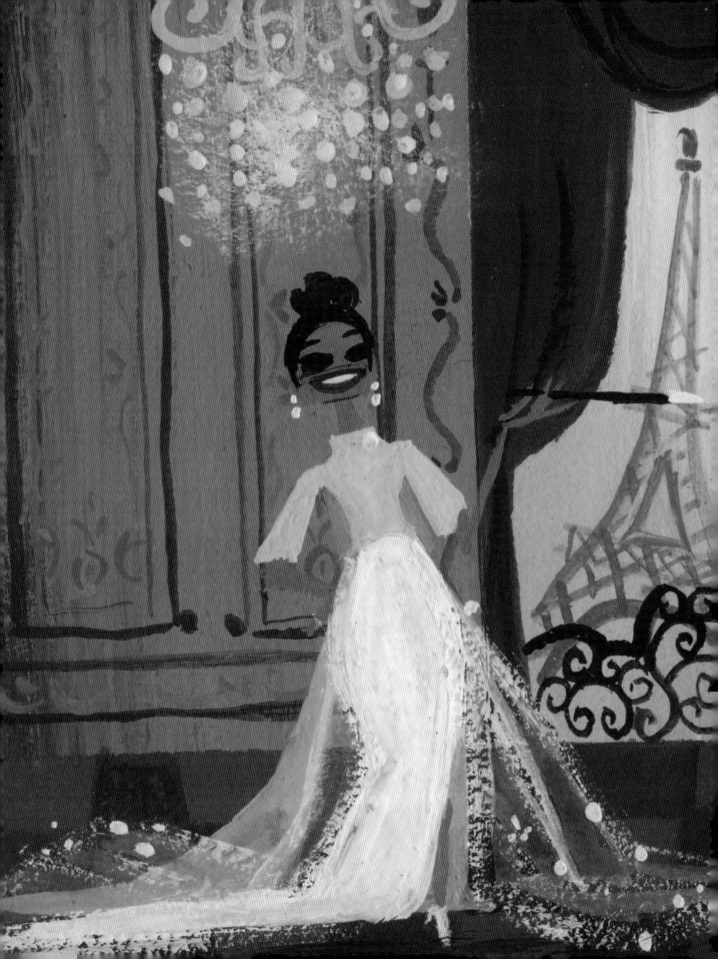

Lorelay Bové

When I was young I loved watching old classic Hollywood films and Disney animated cartoons, and I think it shows in my art today. I have a tendency to paint stories, as well as events from my life and travels. I think it's fun to capture the sincerity and feelings of my day-to-day life and translate it into my work. I believe it makes it all more real and easier for an audience to connect with. All in all, it's very fulfilling when the viewer giggles and understands it, which makes me happy and drives me to experience life even more. Life is what inspires me.

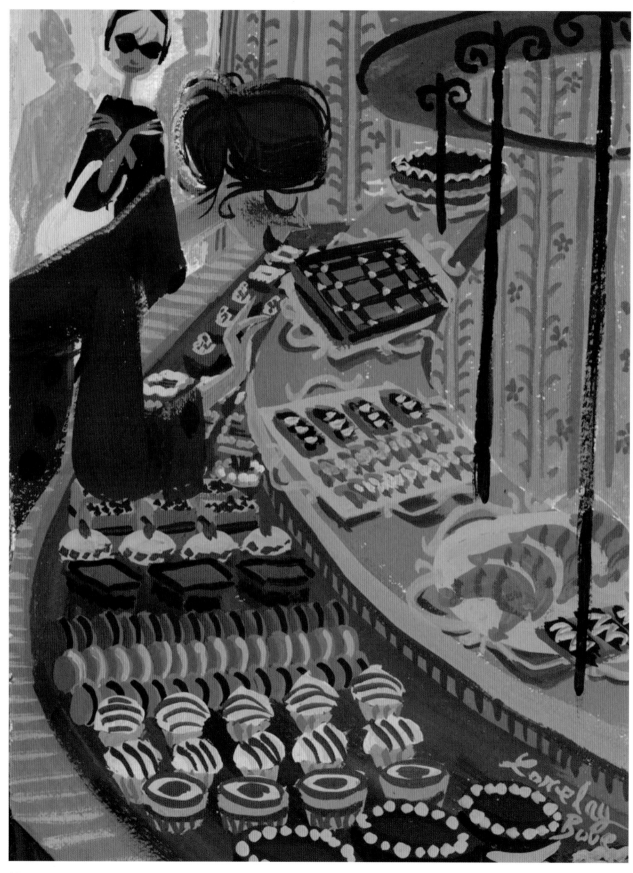

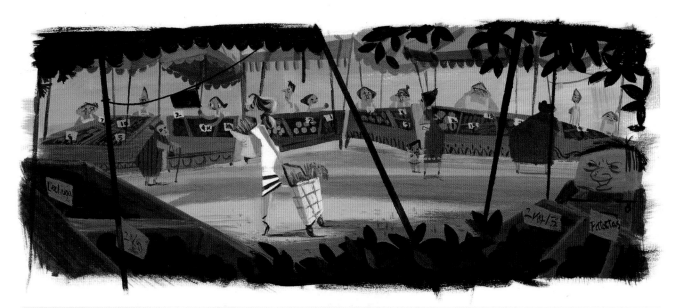

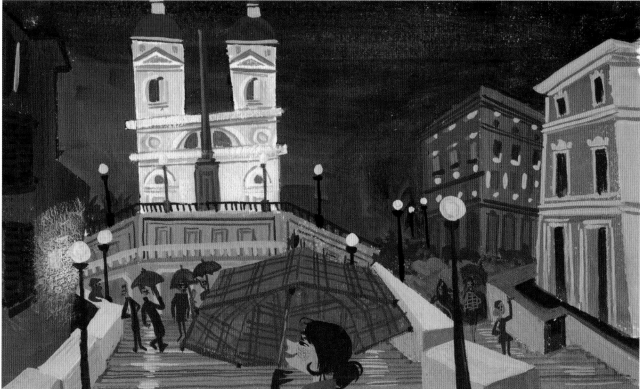

TRAVEL

I love to travel; to see, hear, and feel new things. I paint from my trips and try to capture those feelings in my own way. From the pretty desserts and sweets in Paris to the fresh smell of vegetables in the street markets of Spain, I love the visceral pleasures of travel, like the feeling of rain from Rome while walking down the Spanish Steps.

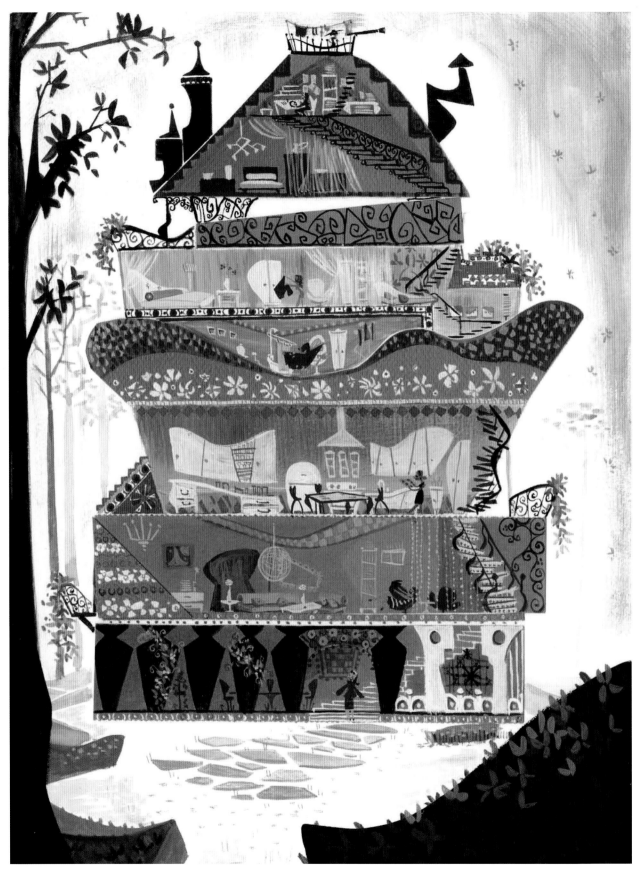

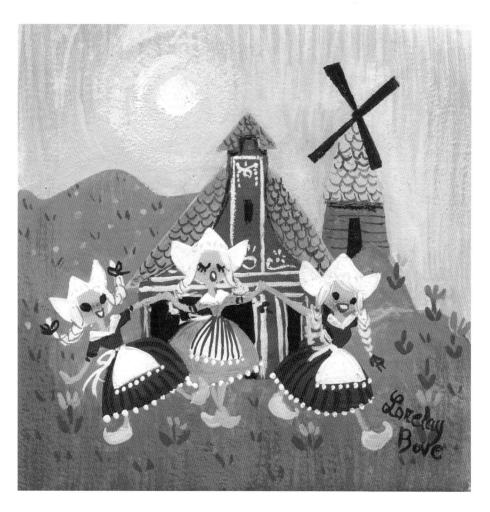

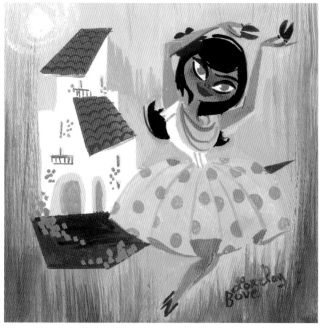

DREAM

I once painted my dream house. I had envisioned a big adorable house in the woods, with a Spanish style mixed with a sort of 1950s decor. The first floor would have a cool patio for tea parties and cocktail nights. The kitchen would be the center of the house—its "belly," so to speak. The bedroom would be soft, pink, and quite feminine, and of course my studio would sit at the very top of the house. I generally like small workspaces; it just feels more cozy. But above all of that, on the very top of the roof, I'd have a place where I can spy and discover new locations and inspirations. For this piece I used paper cutouts and painted over them with gouache. I was inspired by the Spanish architect Antoni Gaudí. I love the organic shapes and sense of whimsy.

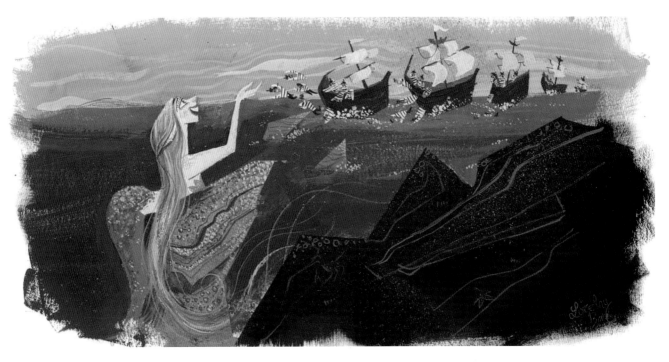

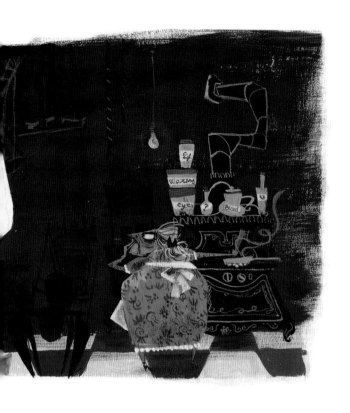

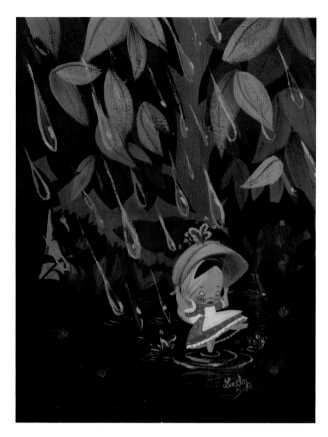

FAIRY TALES

It's always great fun to do your own interpretation of fairy tales, because you can create your personal vision of what the tone of the story is and how it is told through color and mood. One of my favorite stories is *Alice in Wonderland*. It would be so much fun to be tiny in a big world and experience fantastic adventures like she does.

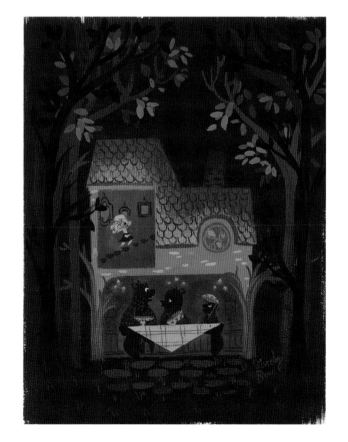

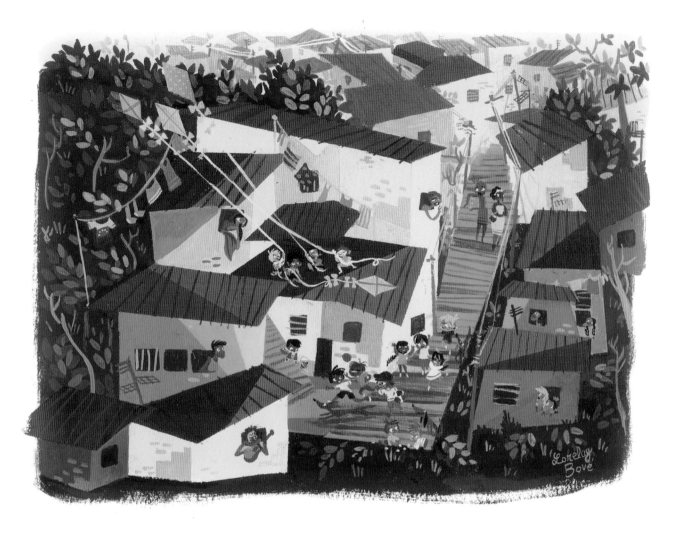

ARCHITECTURE

I love architecture of all sorts. I always like to draw and paint graphic representations of different styles of houses and towns.

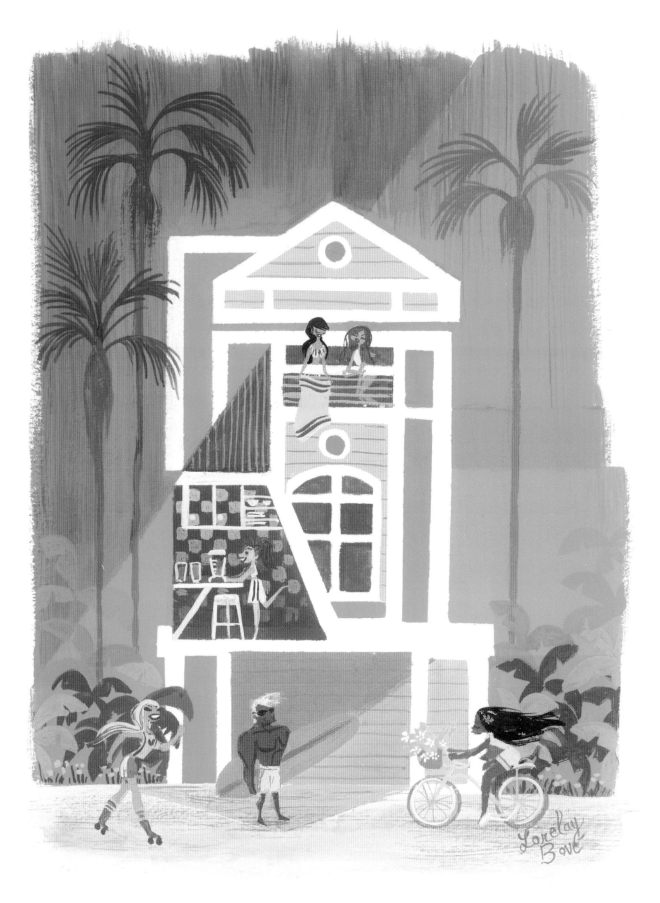

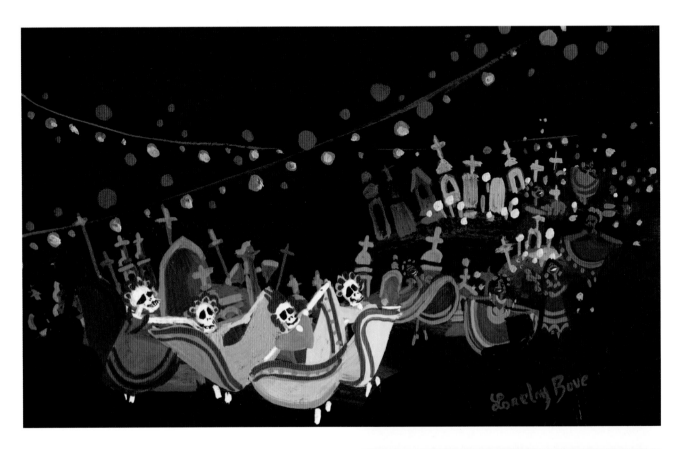

COLORFUL
SKULLS

Día de Los Muertos is a Mexican celebration for beloved friends and family that have died. The celebrations always use a very colorful, vibrant palette, and I love it! So festive and lively!

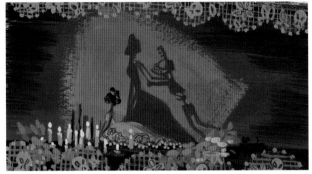

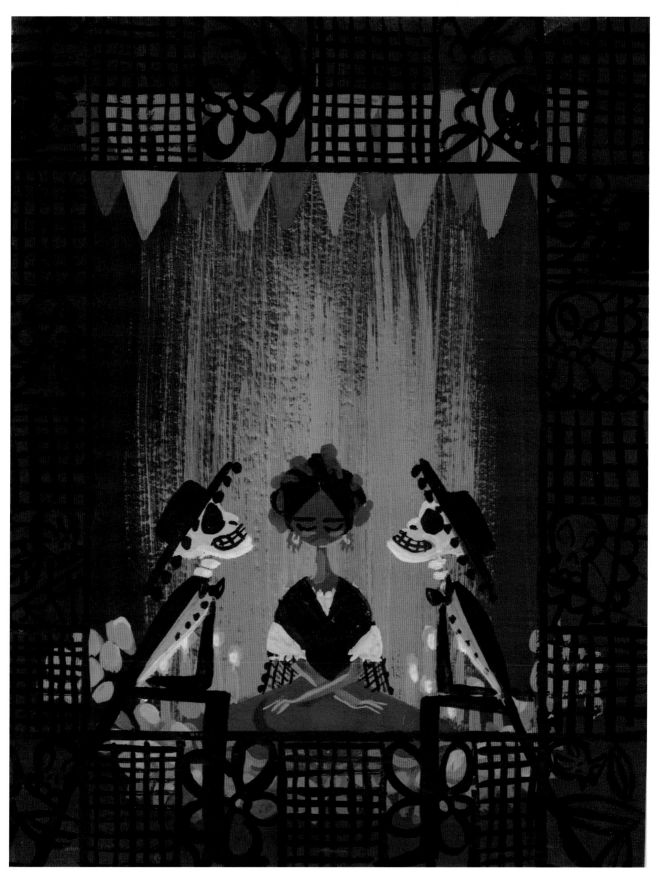

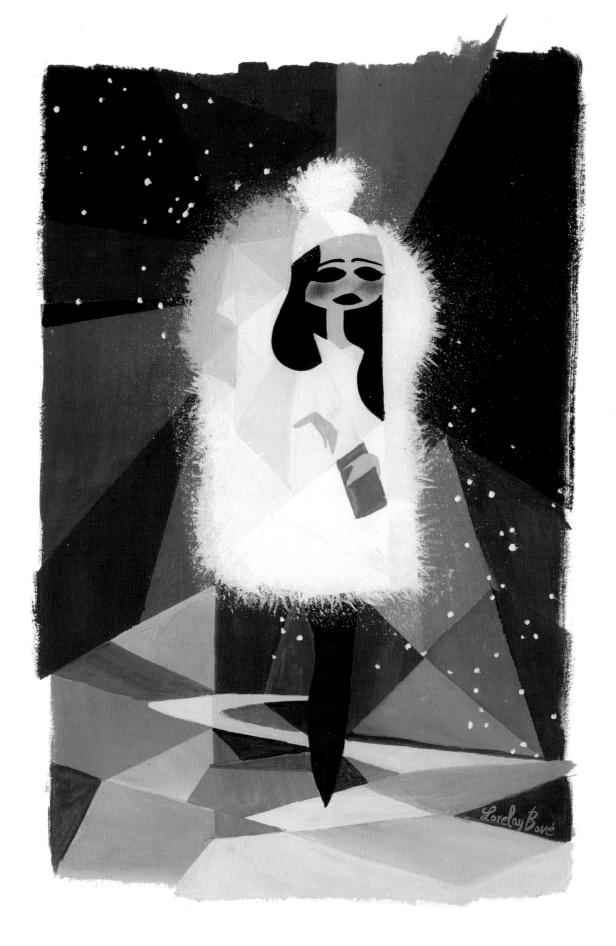

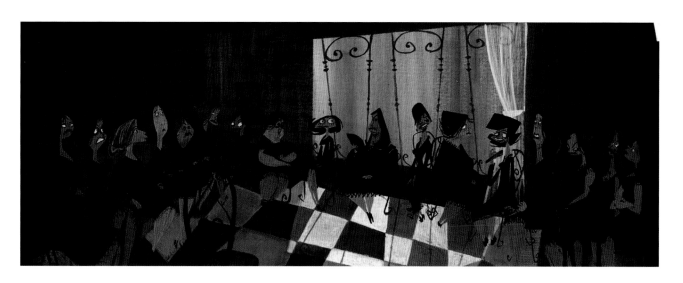

FILM AND FASHION

I really love the movie Volver. When I first saw it, I was inspired to paint the ladies in black. Though they were all wearing black, they all had such distinct and authentic personalities, so I decided to caricature them and that moment.

SEASONS

I'm not a big fan of winter, but I am a fan of fluffy white coats. I was painting a set of the 4 seasons, and tried to capture what each season's feeling meant to me.

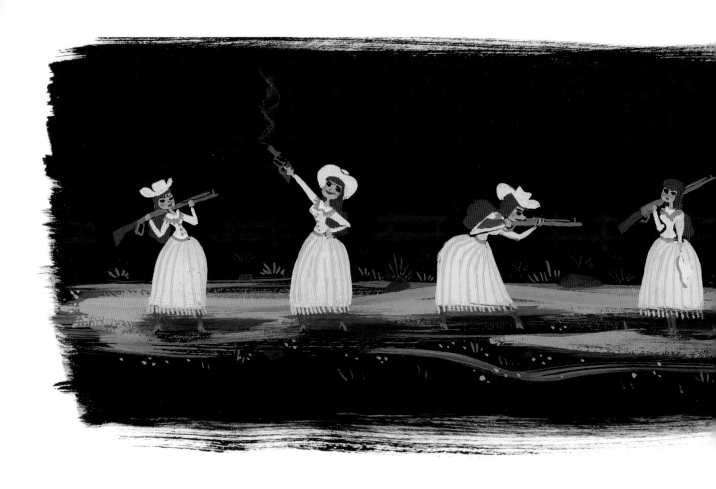

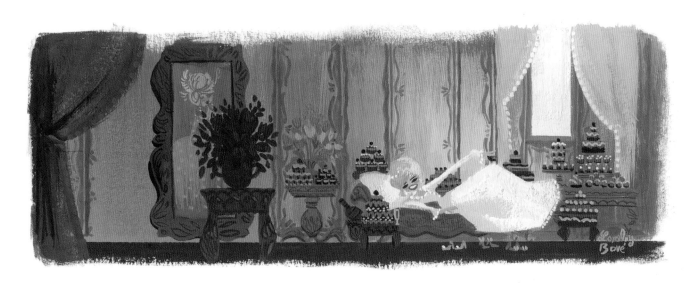

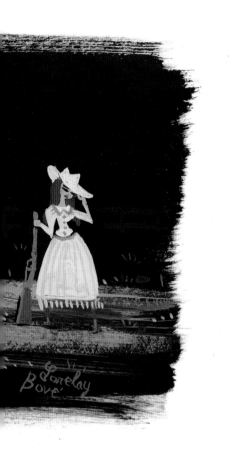

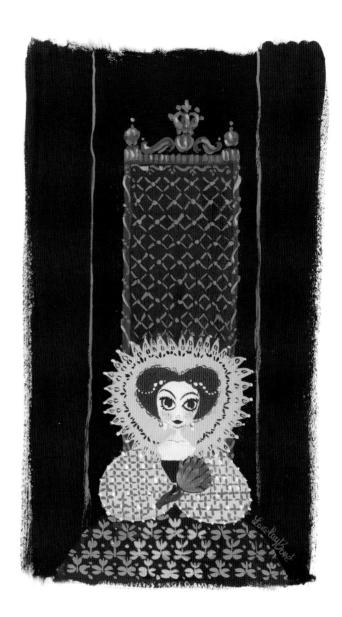

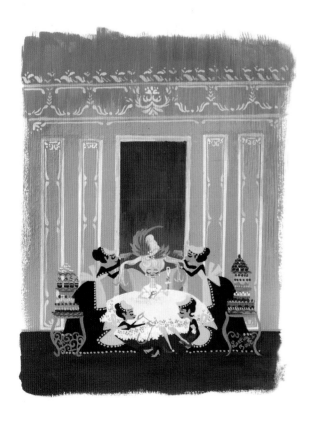

LADIES

Legendary Beauties was an art show I did with Brittney Lee, and we did an homage to many wonderful women legends, fictional and nonfictional. I love them all, from the power of Annie Oakley, to the elegance of Marie Antoinette, to the imposing attitude and appearance of Queen Elizabeth.

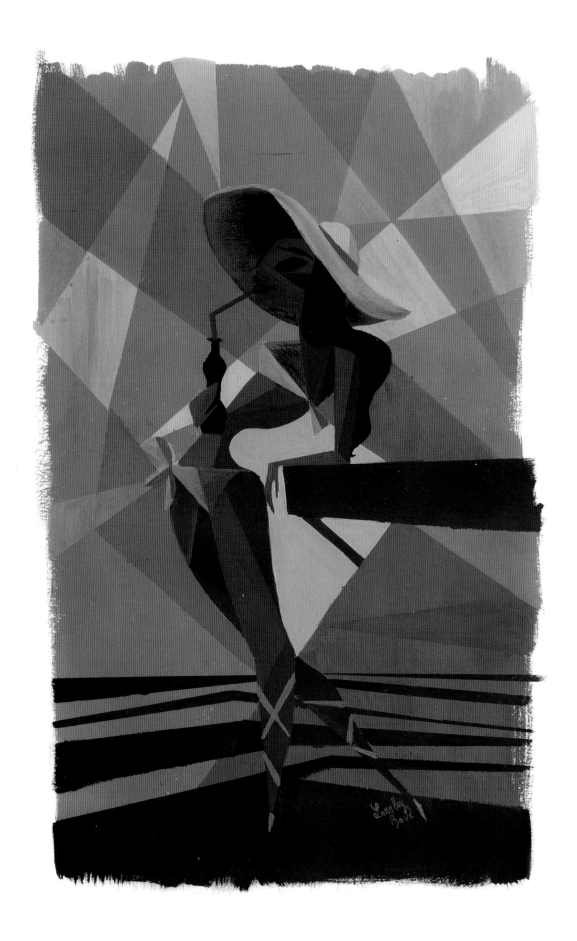

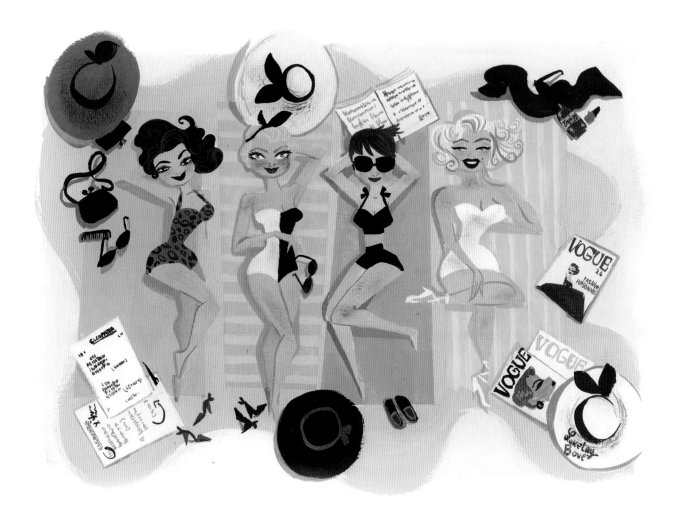

SUMMER

Summer is my favorite season, full of warm colors and fun. Plus, there are vacations and hanging out at the beach all day! I thought it would be fun to make a painting of Elizabeth Taylor, Grace Kelly, Audrey Hepburn, and Marilyn Monroe tanning and spending a day together like friends, in classic Hollywood style.

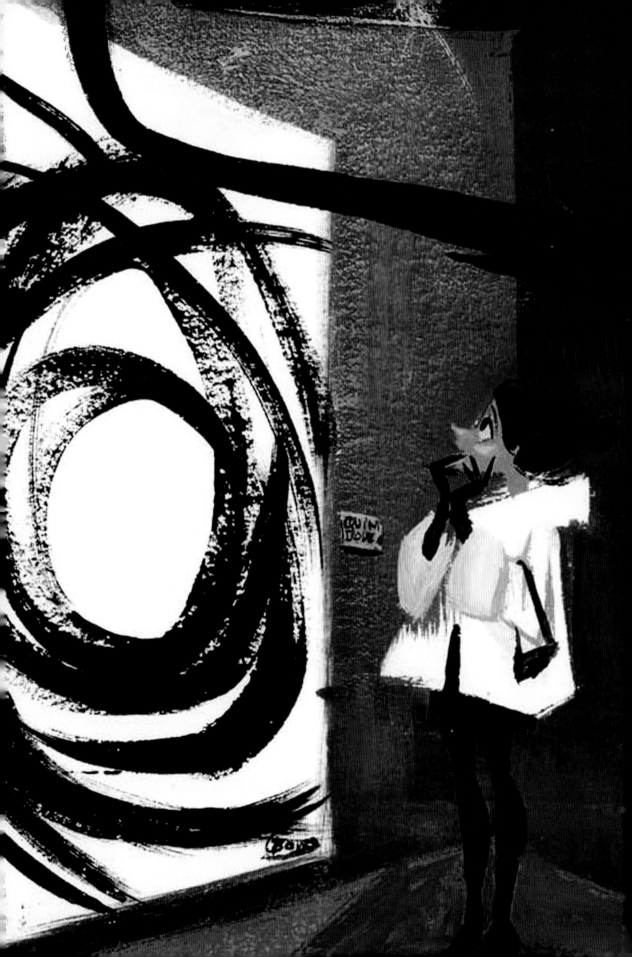

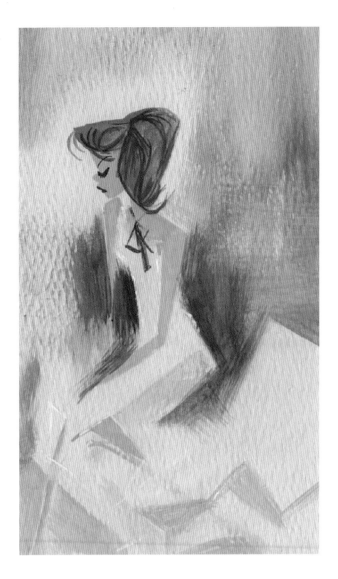

EXPLORE

One of my inspirations is my dad, Quim Bové, a contemporary abstract painter. Once I painted a girl contemplating his painting in an art show. Maybe the girl is me—many people think that, even though I didn't plan on it. Sometimes I like to add a little more design into my art and try new techniques to expand my aesthetics, but I always try to maintain my own artistic style, my individuality as an artist.

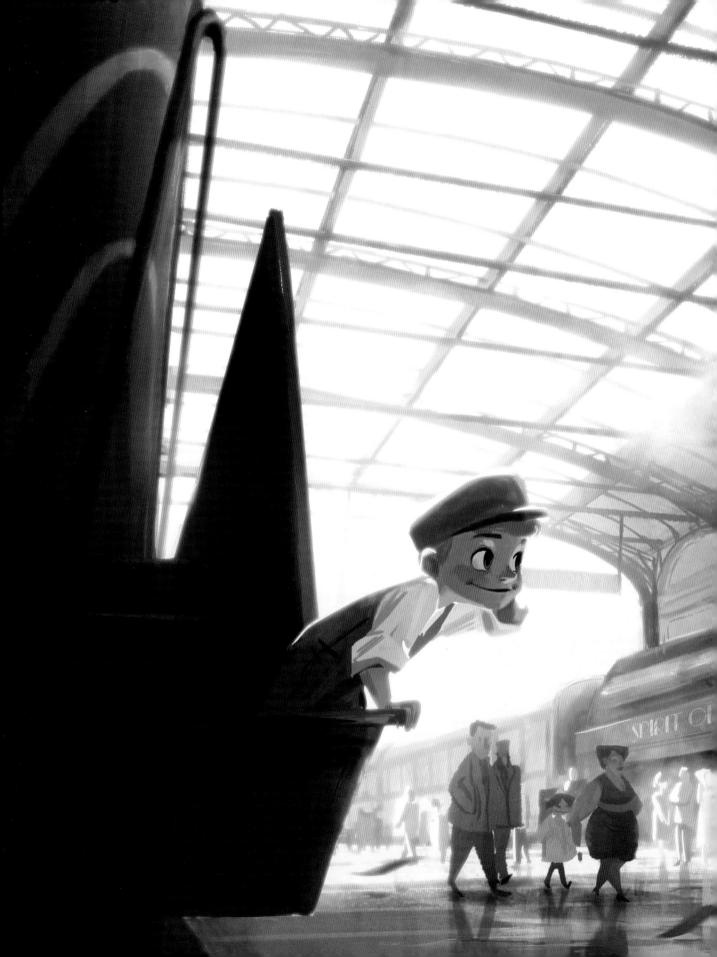

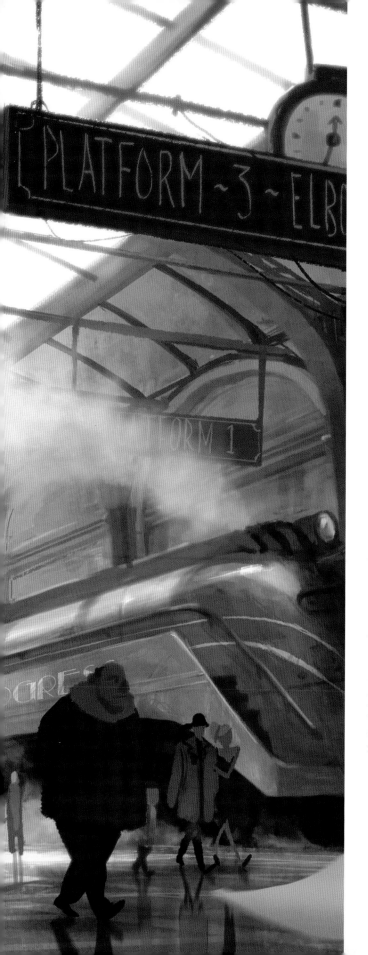

Mingjue Helen Chen

When I was a kid, becoming a professional artist didn't seem like a possibility. I drew mainly for myself. It wasn't until I was around 16 that I decided to pursue art as a career. I'd make a terrible dentist, so I went to an art college right after high school, and I haven't looked back. I'm constantly putting pressure on myself to continue to learn and grow. Knowing how far I have yet to go, I'm grateful for the time I've had since graduating to learn as much as I can as a working professional, and I hope it continues!

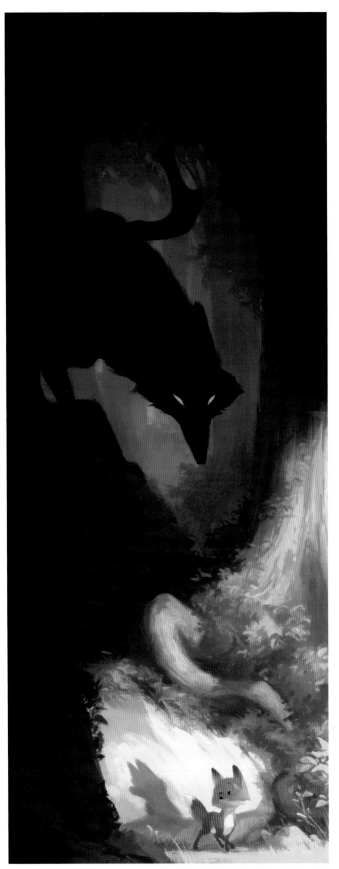

LITTLE RED

These paintings were done when I was at Disney Animation as a trainee. It's a twist on the classic tale of Little Red Riding Hood, where I used a small fox instead of the little girl we so often see. I wanted to explore different color palettes and a variety of different compositions. At the end of the six-month training period, I was hired full-time as a visual-development artist.

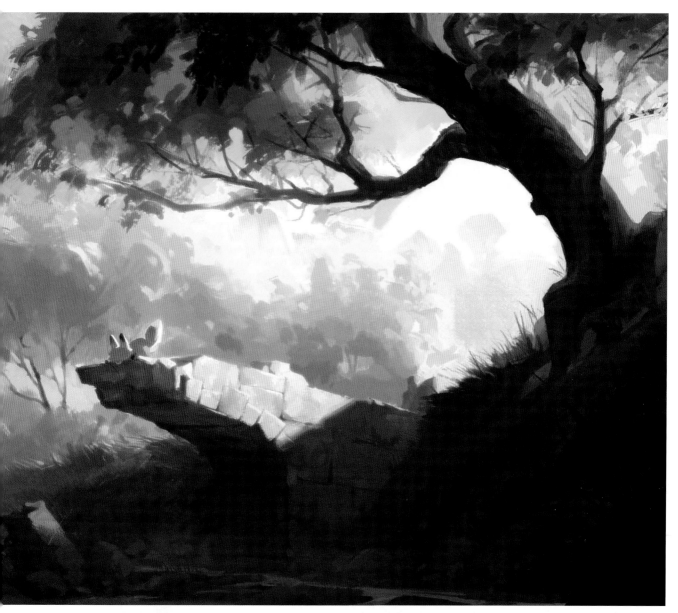

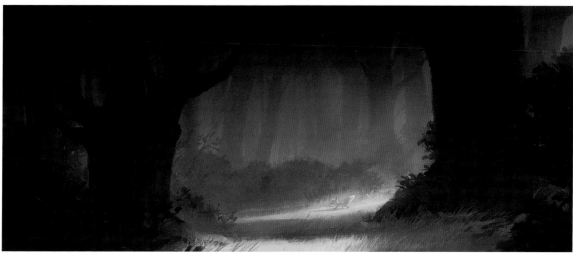

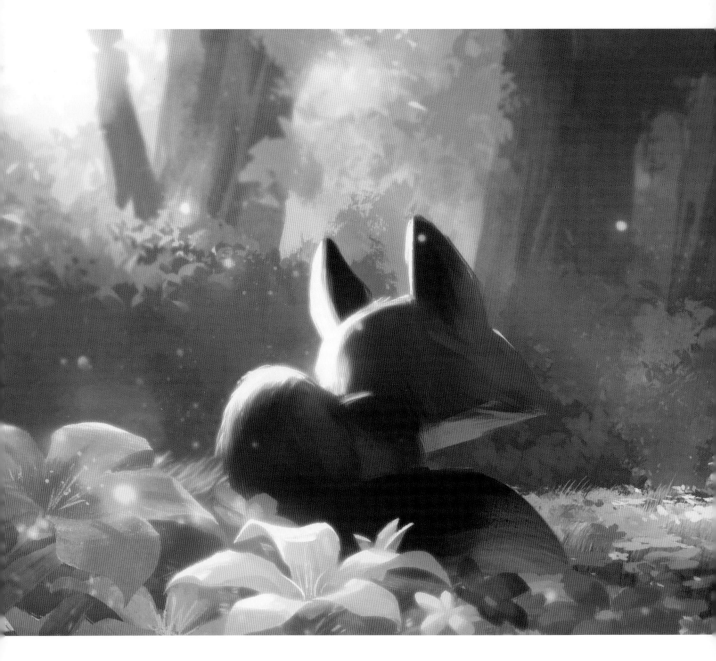

HIDDEN

This was one of the last paintings I did, where my Little Red arrives at Grandma's house. The scene is supposed to be beautiful, yet feel not quite right, which I played up with the color of the flowers and the very dramatic lighting. The composition is rather static, but I think of this moment as the calm before the storm, which is meant to build tension to the final scene in which the wolf attacks Little Red.

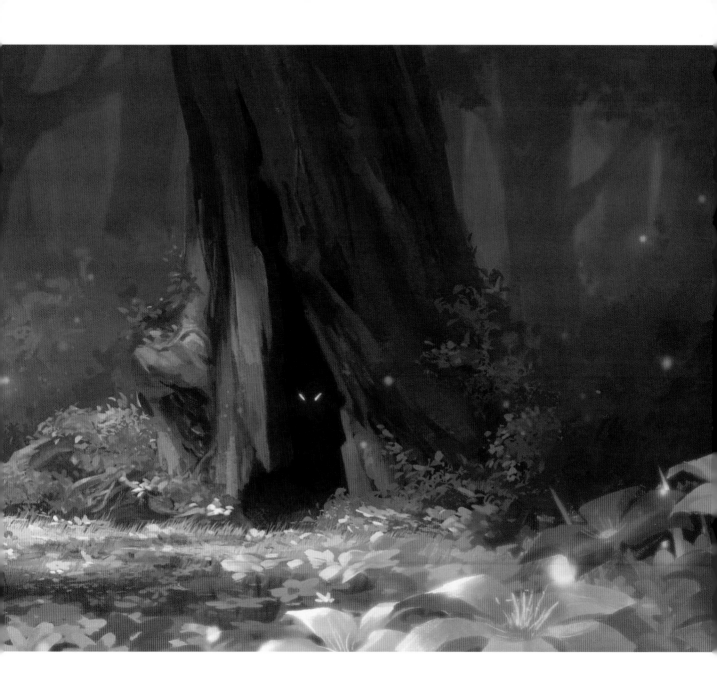

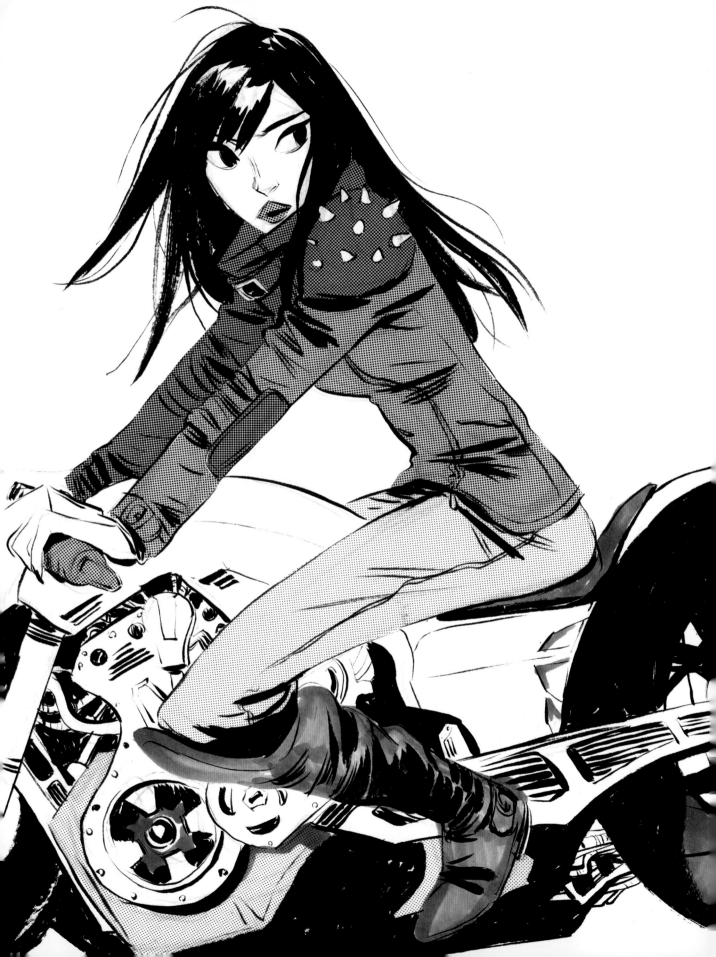

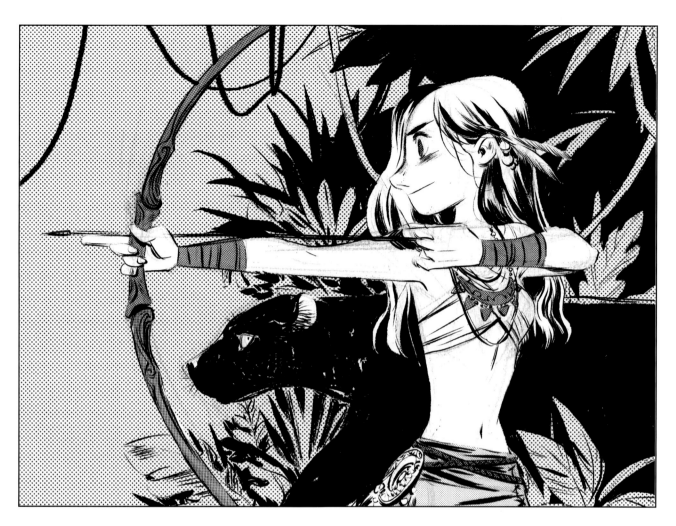

INK AND SCREENTONE

This year, I really fell in love with drawing again. At the studio, I'm constantly painting digitally, so finding time to unwind with actual drawing has been very therapeutic. Growing up, I was a huge fan of Japanese comics and animation. That influence is still very apparent in my personal work. I use analog screentone on top of ink drawings to give an otherwise boring drawing more interest. Plus, it's just really fun to experiment with and use!

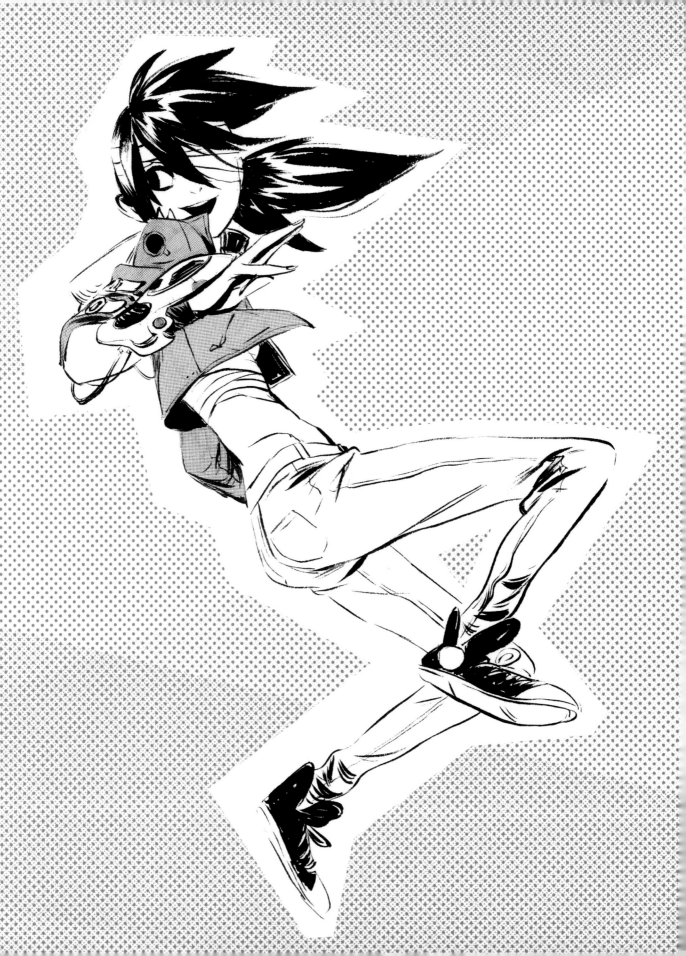

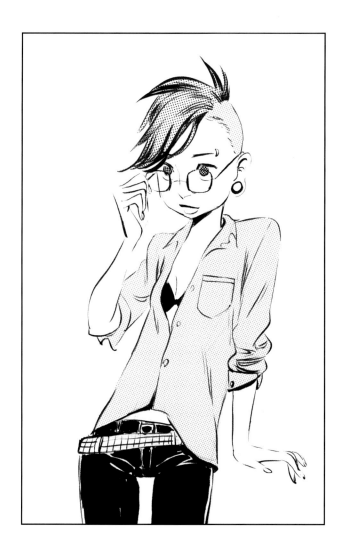

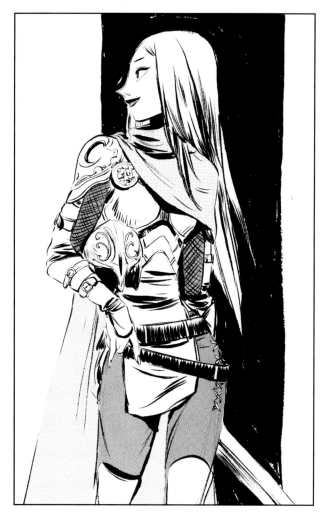

GIRLS!

I love drawing girls, since they're a great subject for appealing drawings. These are drawings I did while at home purely for the sake of fun. It's hard for me to tell what exactly I'm in the mood to draw, so every image I start is a sort of mystery until I'm finished. It definitely helps me overcome the pressure of doing great drawings all the time, and allows for mistakes!

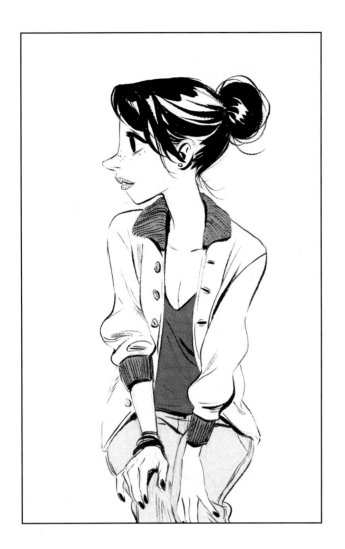

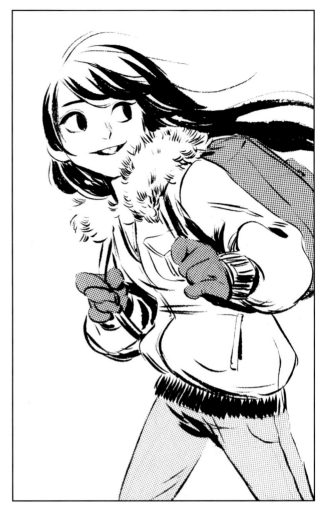

MORE GIRLS

Clothed figure drawing was one of my favorite classes when I was in school, but it took me years to translate what I learned from drawing off a model into creating my own figures and draping clothes on them. I still don't feel completely comfortable with that particular skill, but that's okay, because I know I'm learning every time I draw.

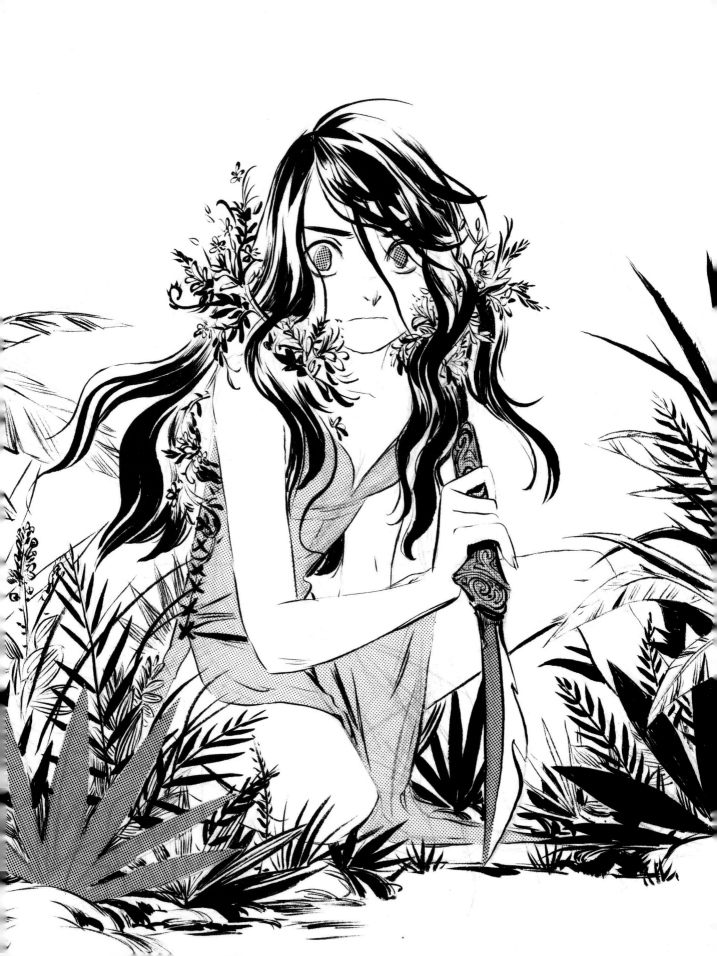

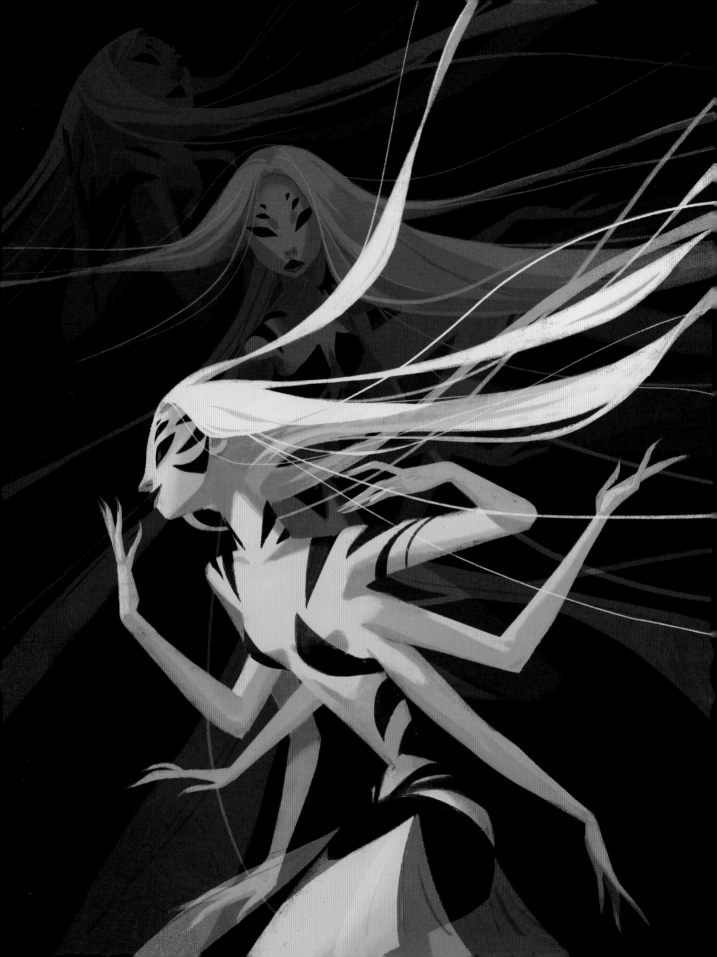

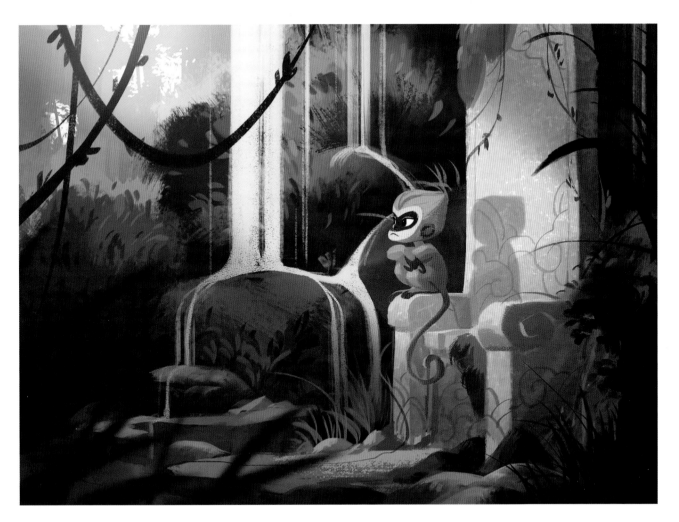

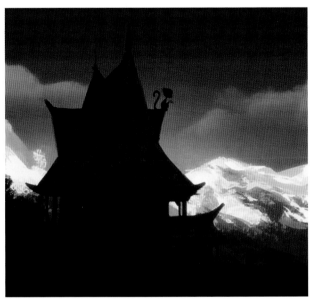

THE MONKEY KING

One of my favorite childhood fairy tales was The Monkey King. As a Chinese artist, I'm always looking for ways to incorporate my cultural identity into my work. On his journey as a bodyguard for the Tang priest, the Monkey King meets many unique allies and fantastical villains, like a den of spider demons intent on ensnaring the Tang priest. The fantastical landscape of this classic Chinese fairy tale was the perfect inspiration for me.

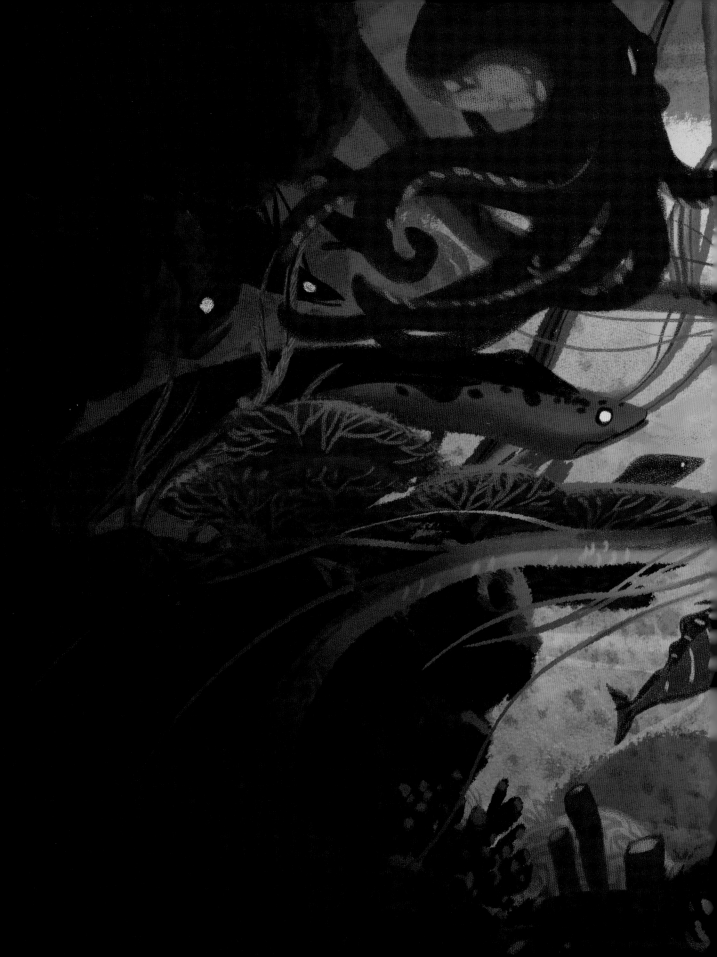

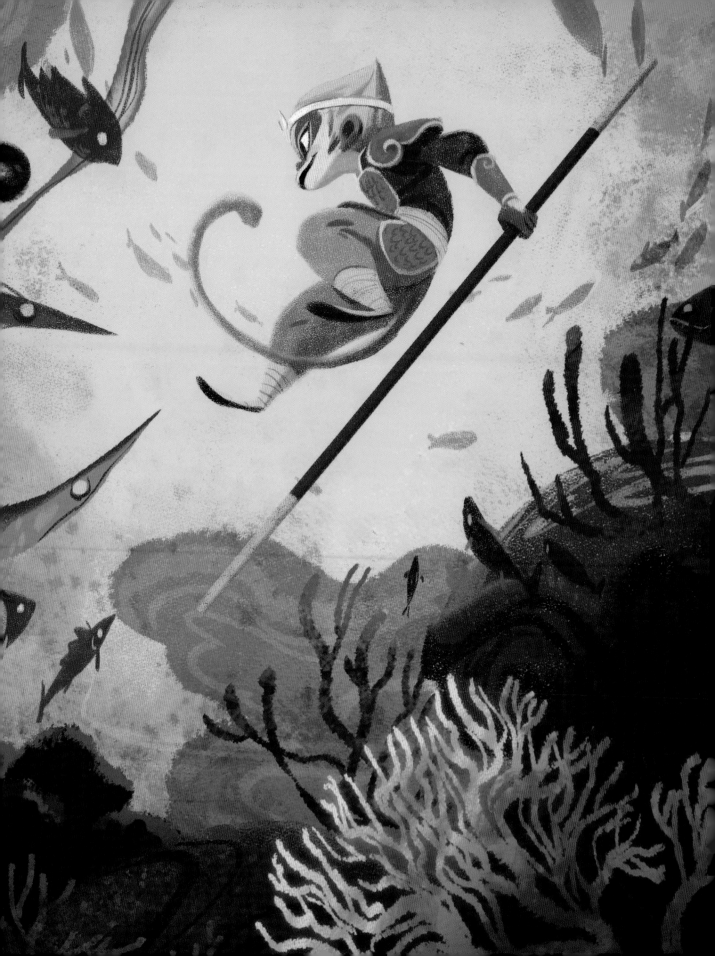

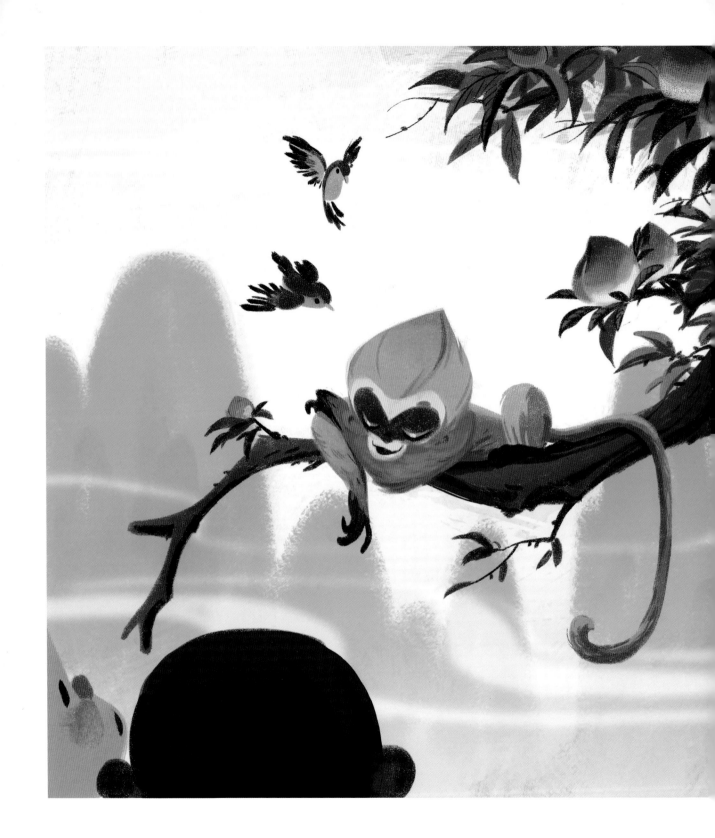

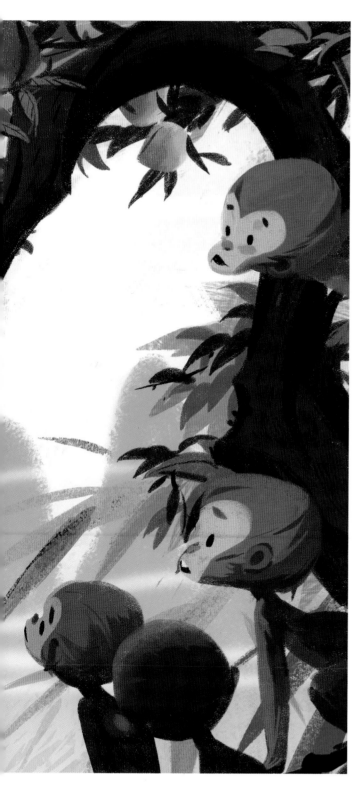

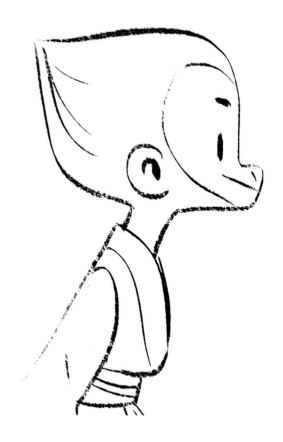

A YOUNG MONKEY

The story of the Monkey King, or Sun Wukong, sweeps across hundreds of years, starting with a peculiar monkey born from a stone egg and following him to his ascension as a king of the Flower and Fruit Mountain. Here Sun Wukong is sleeping in a peach tree, surrounded by the other monkeys who will eventually name him king.

IRON FAN

Princess Iron Fan was one of my favorite characters in the stories. Married to the Demon Bull King, she was a beautiful goddess who wielded a magical fan. In the stories she was always more passive than I would have liked. So I decided to take her story and make her the warrior, instead of her husband. The magical fan that is vital to Sun Wukong and company traversing the Flaming Mountains is now a weapon she can wield against Sun Wukong. In the original story, she tricks the Monkey King into believing the fan she gave him was the real thing. This is one of precious few instances of the Monkey King himself being tricked by anyone!

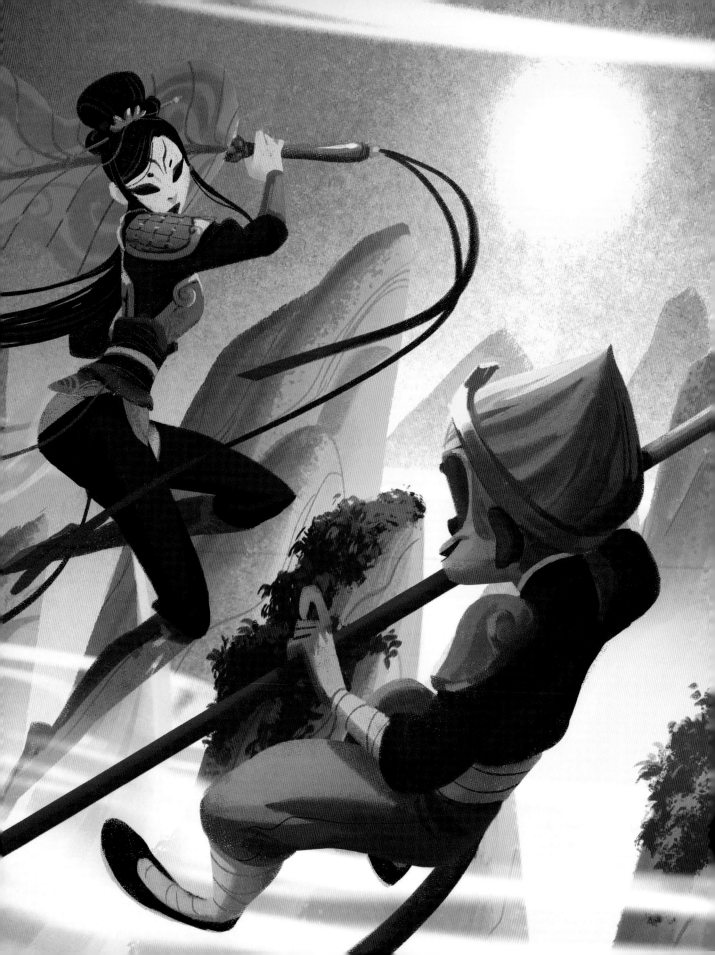

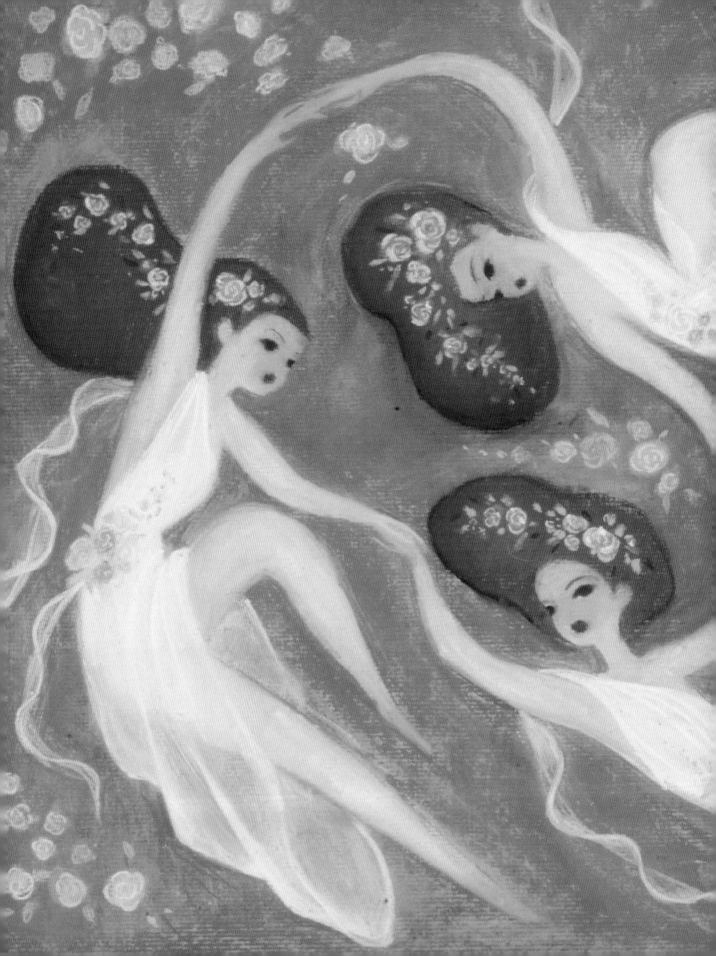

Claire
Keane

What excites me most about working as a visual-development artist in animation is the challenge of telling an entire story in one image. I love working in that way so much that when I was asked to be in an art show featuring personal work I had a hard time knowing what to do. I suddenly realized I didn't know what my personal art would look like without a movie or story propelling it forward.

I found the answer to my struggle at L'Orangerie Museum in Paris, where years before I had discovered the whimsical portraits of Marie Laurencin. They were simply carefree and beautiful. I was inspired. As I worked with pastels, it was as if a whole new world opened up. I was able to enjoy creating without any of the constraints of a story, with nothing but the whimsy of Laurencin's paintings to inspire me. The pastels over the next few pages were my exploration into creating art for the sheer joy of playing with shape and color.

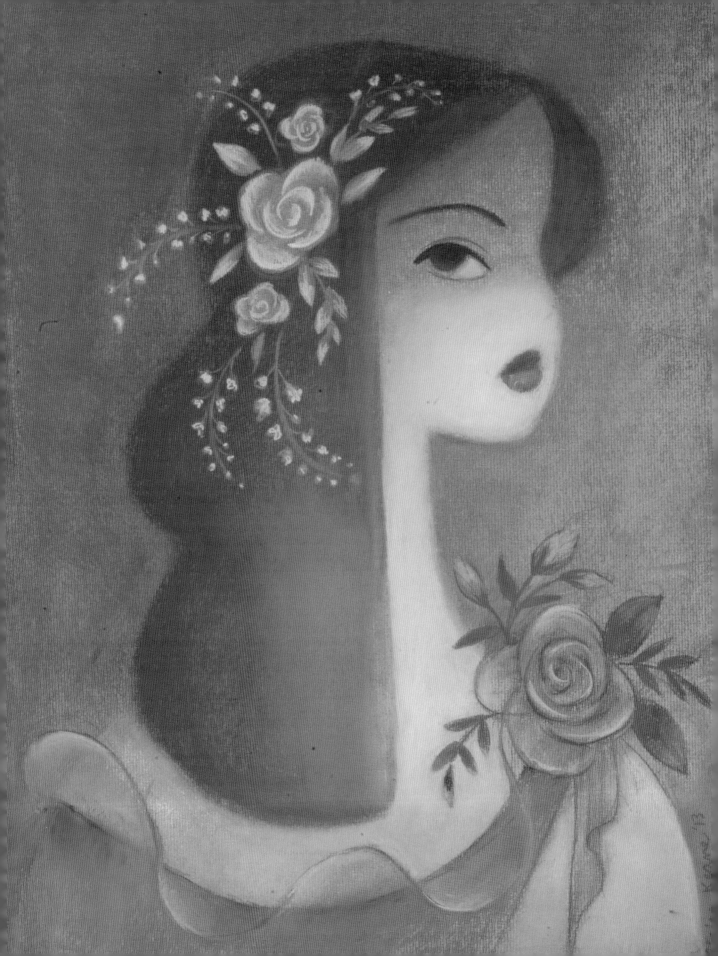

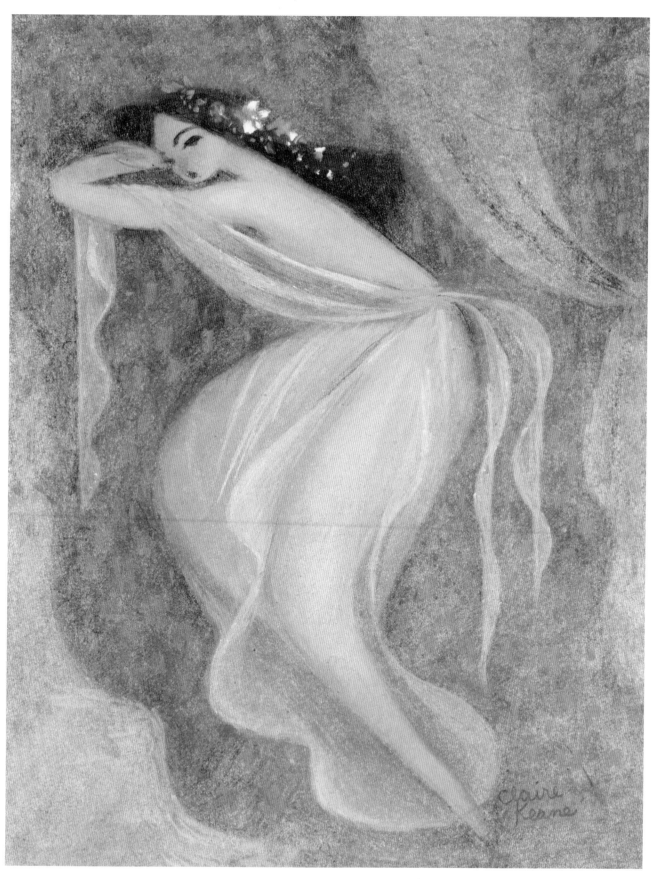

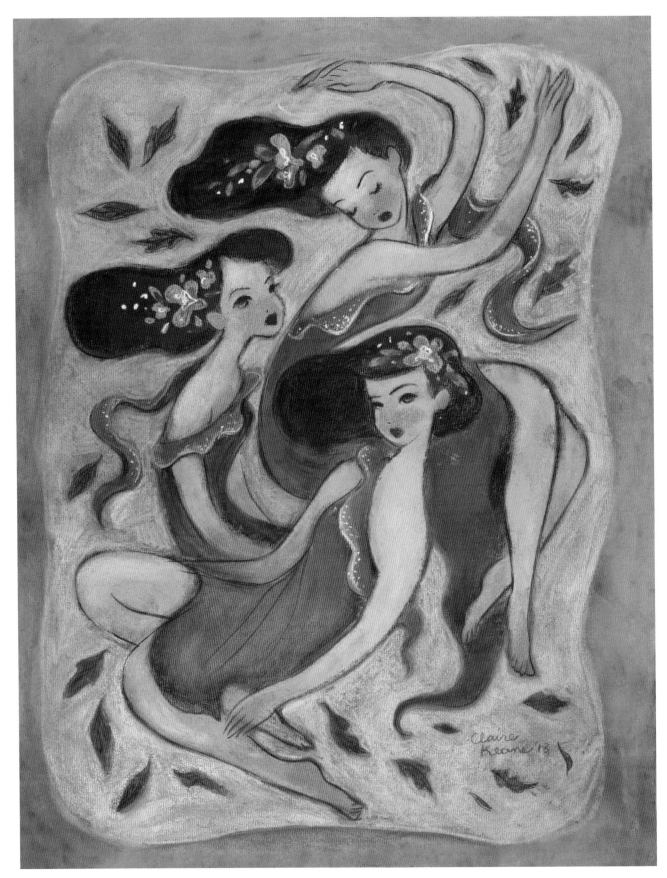

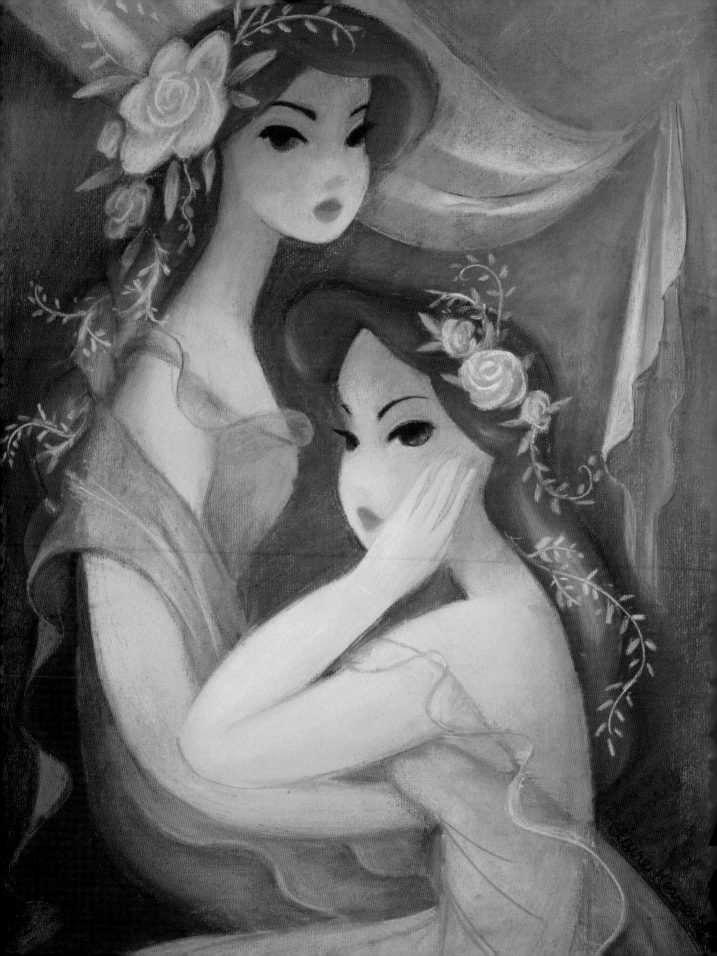

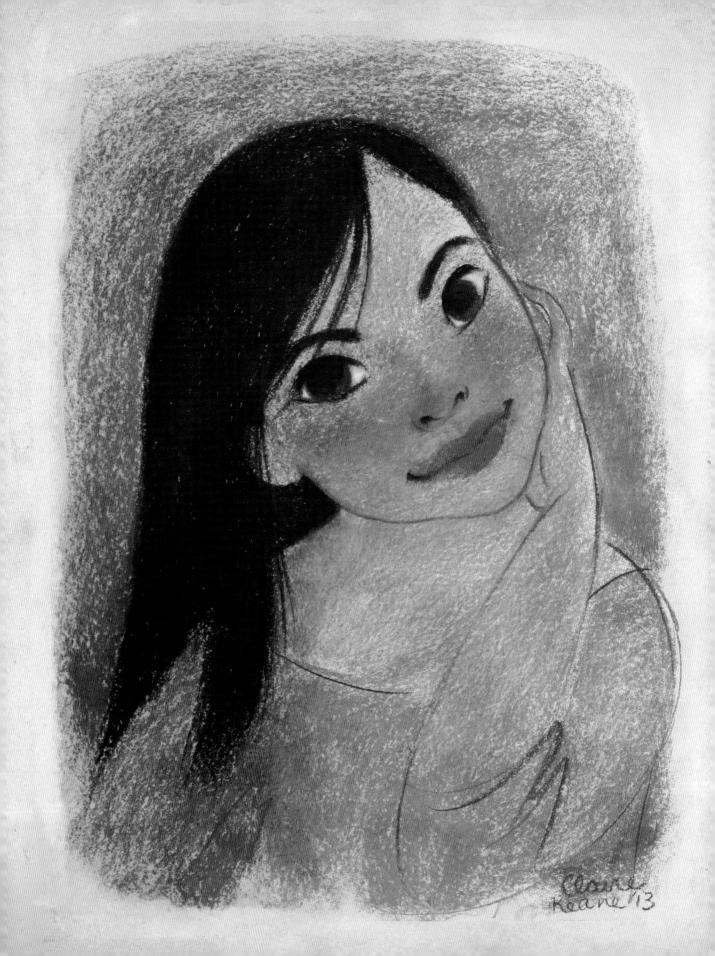

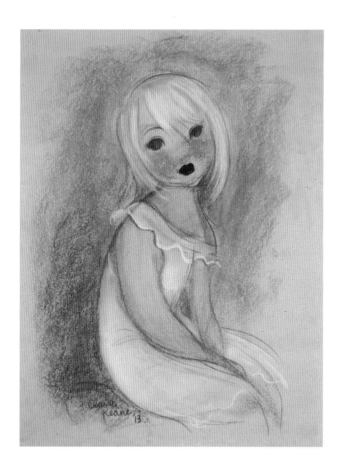

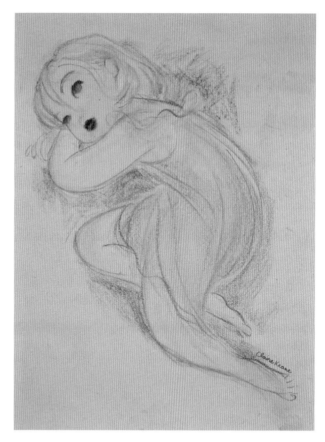

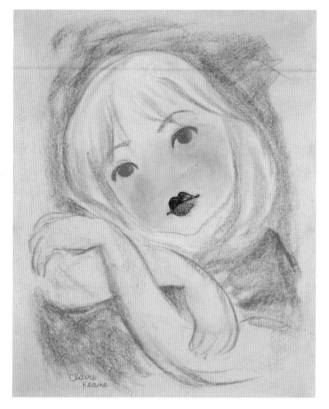

PORTRAITS

I have noticed that my portraits are best done from memory. There is a peacefulness that comes with drawing from memory. Somehow the features can sink in and I remember not only the elements of a face but also the spirit of it.

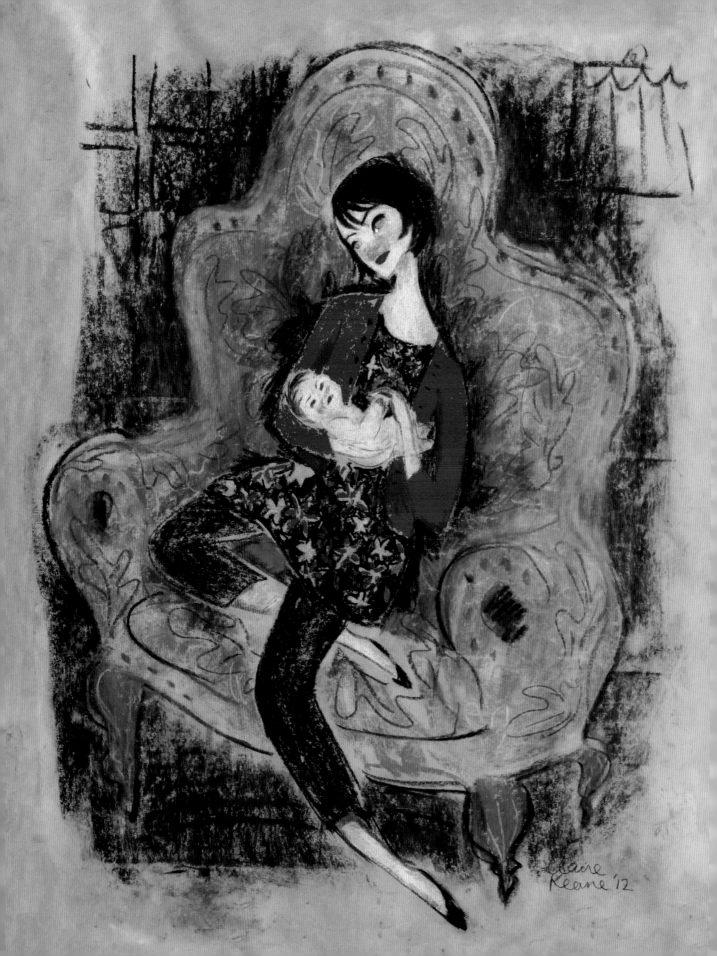

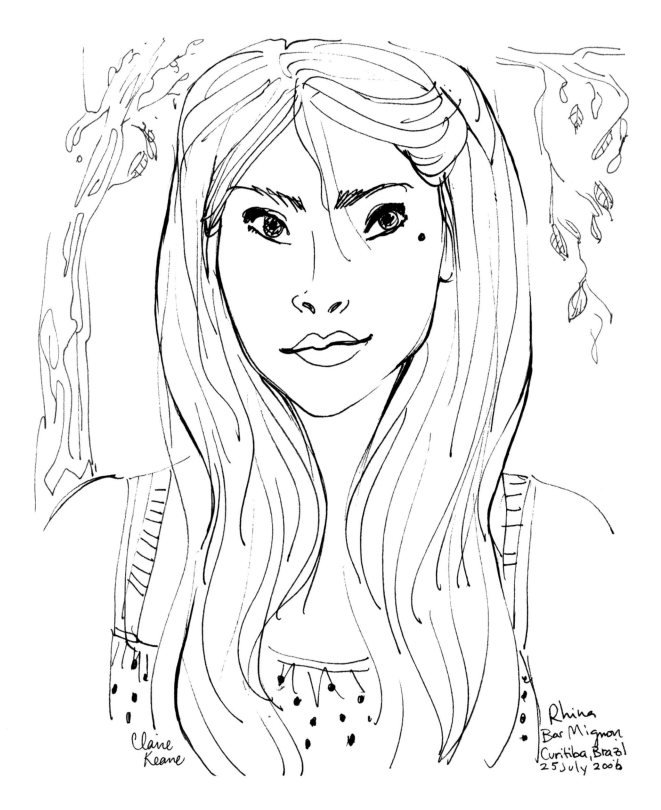

Claire
Keane

Rhina
Bar Mignon
Curitiba, Brazil
25 July 2006

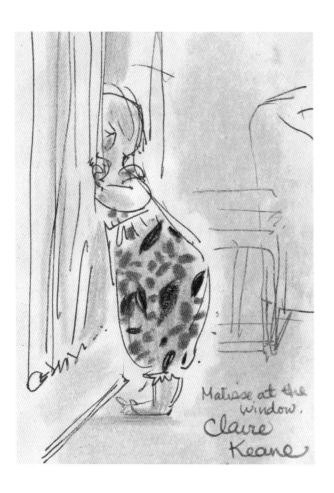

Matisse at the
window.
Claire
Keane

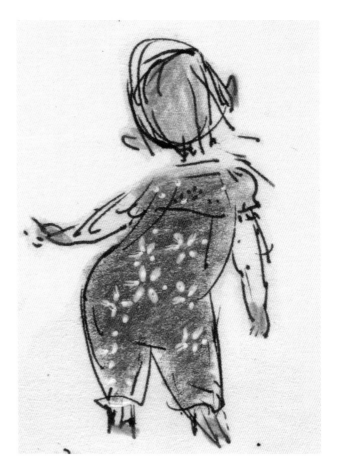

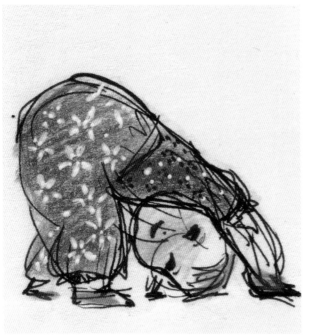

SKETCHING

Drawing has been a part of my life for as long as I can remember. Growing up, I was the subject of many drawings by my father or grandfather. I have kept up the tradition by following my own kids around with a sketchbook. These sketches were of my particularly busy daughter, Matisse, when she was about 1 year old.

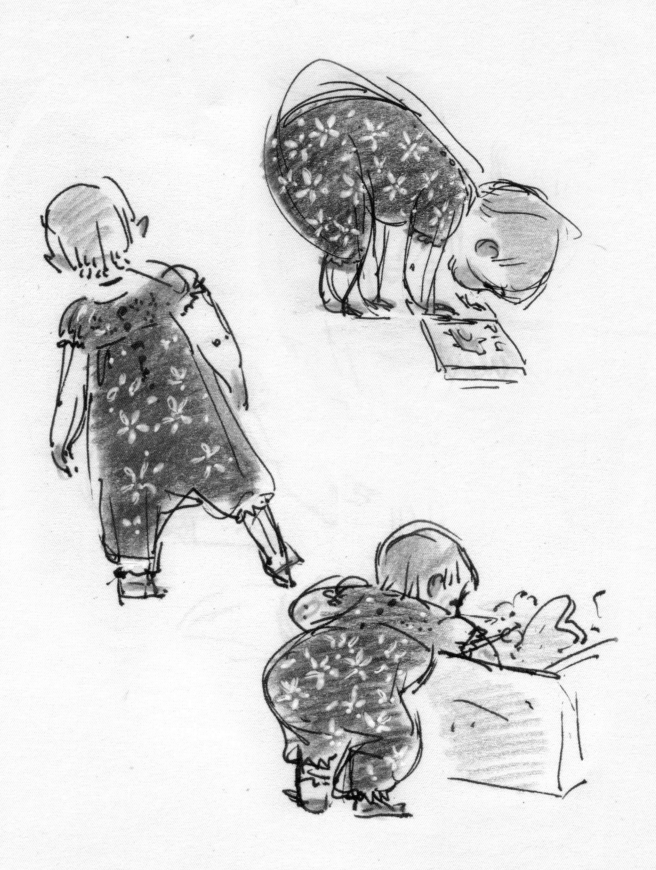

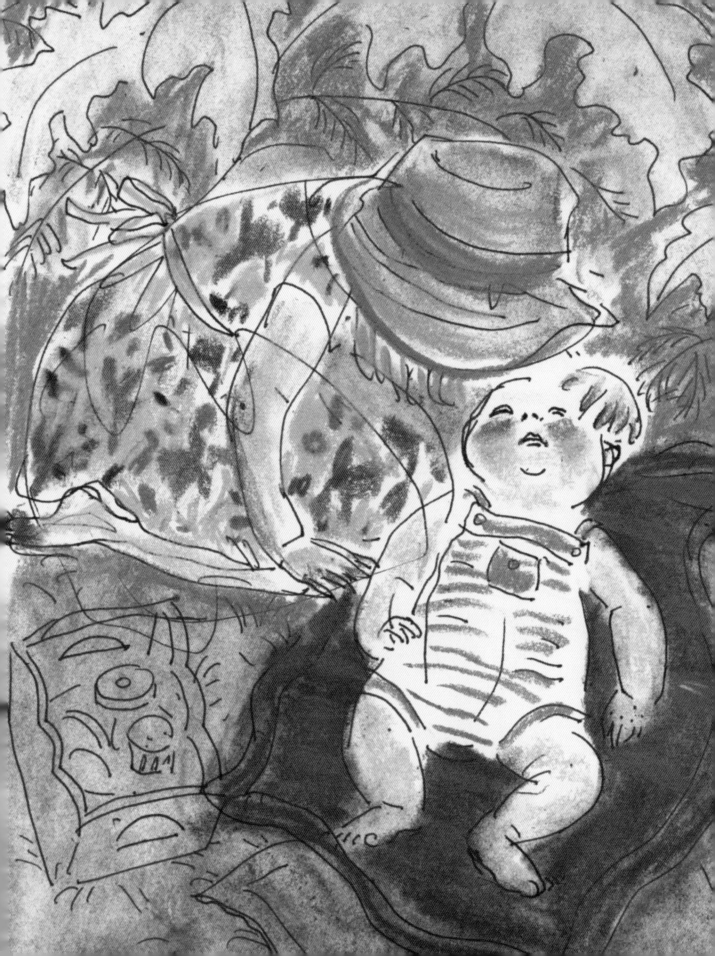

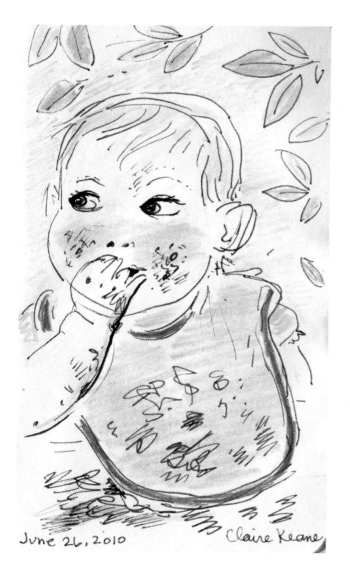

June 26, 2010 Claire Keane

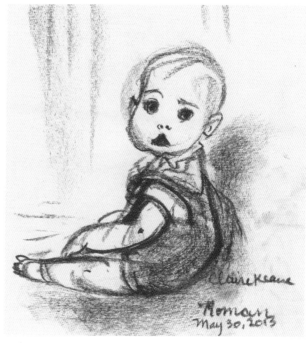

"Moriau"
May 30, 2013 Claire Keane

DRAWING BABIES

My babies have been some of the most challenging things I've drawn. Their faces are so perfect that every little inaccuracy in my drawing is magnified 100 times. Nonetheless, every once in a while I get a drawing in that captures a small part of their sweetness.

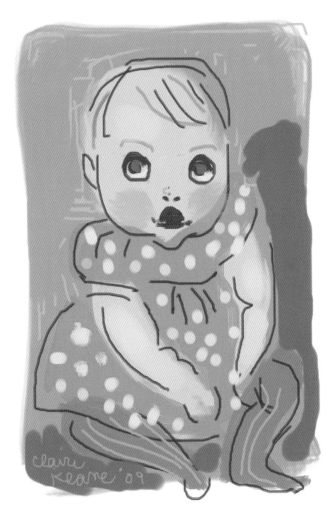

iPHONE SKETCHES

When my husband and I had our first child, I bought an iPhone. Soon I realized the potential of such a small device. I discovered that not only was it a phone, computer, and camera, but it could also be used as a sketchbook.

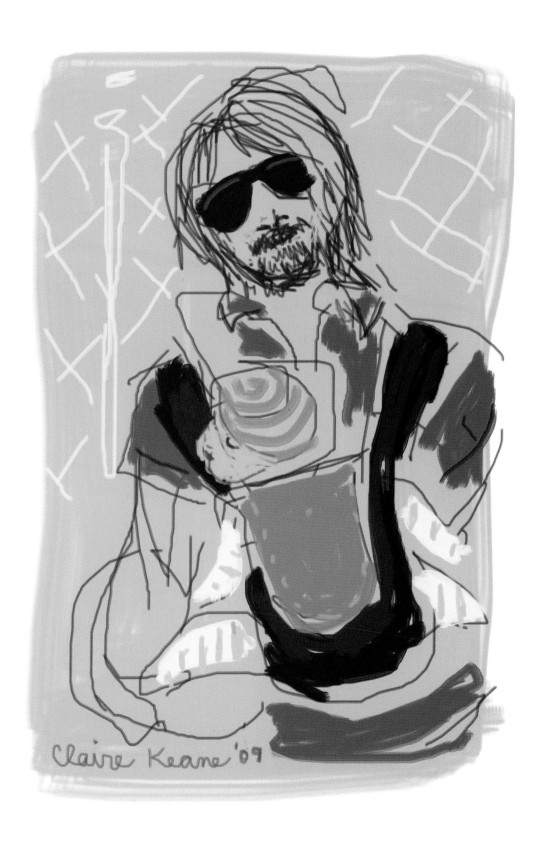

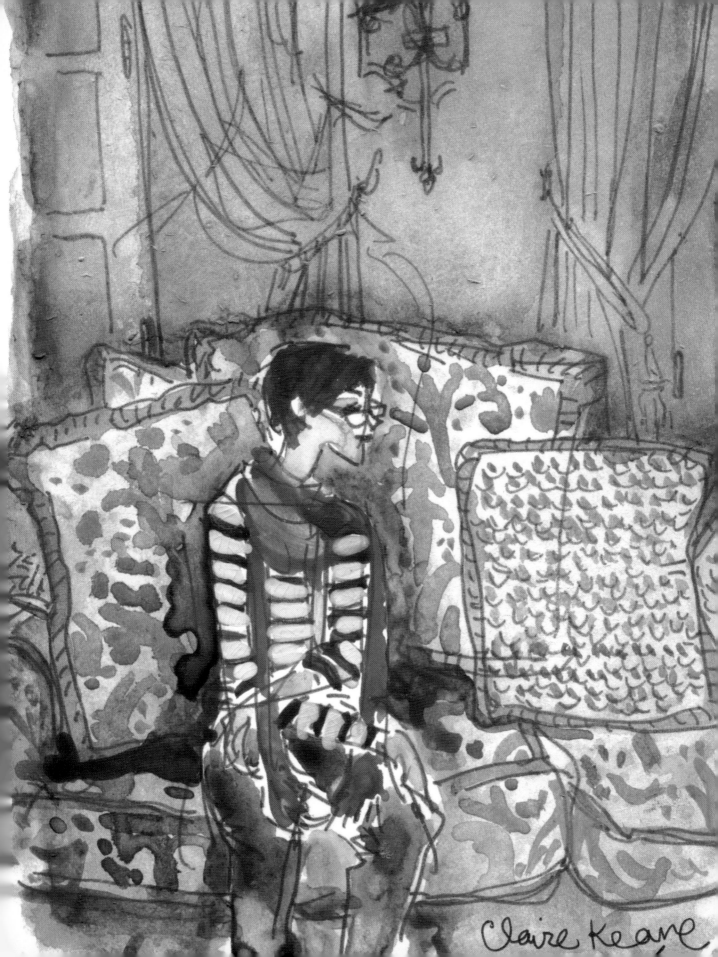

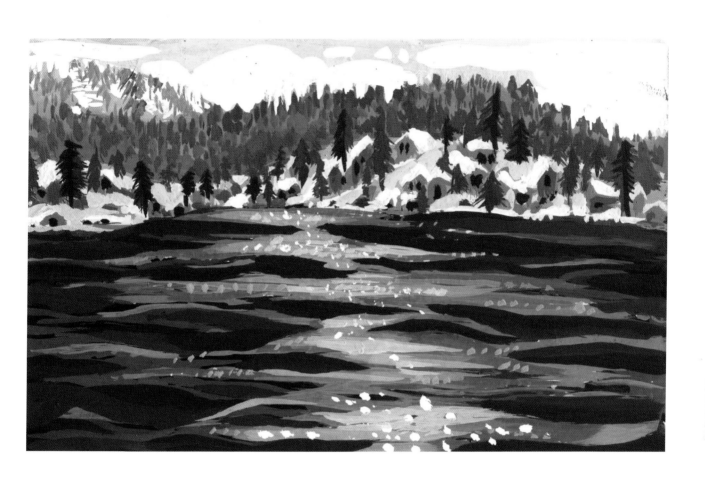

LAKE ARROWHEAD

We spend a lot of time in Lake Arrowhead with my parents who have
a beautiful house on the lake. Some of my favorite moments are when
I get to chat with my mom with a glass of wine and a sketchbook.

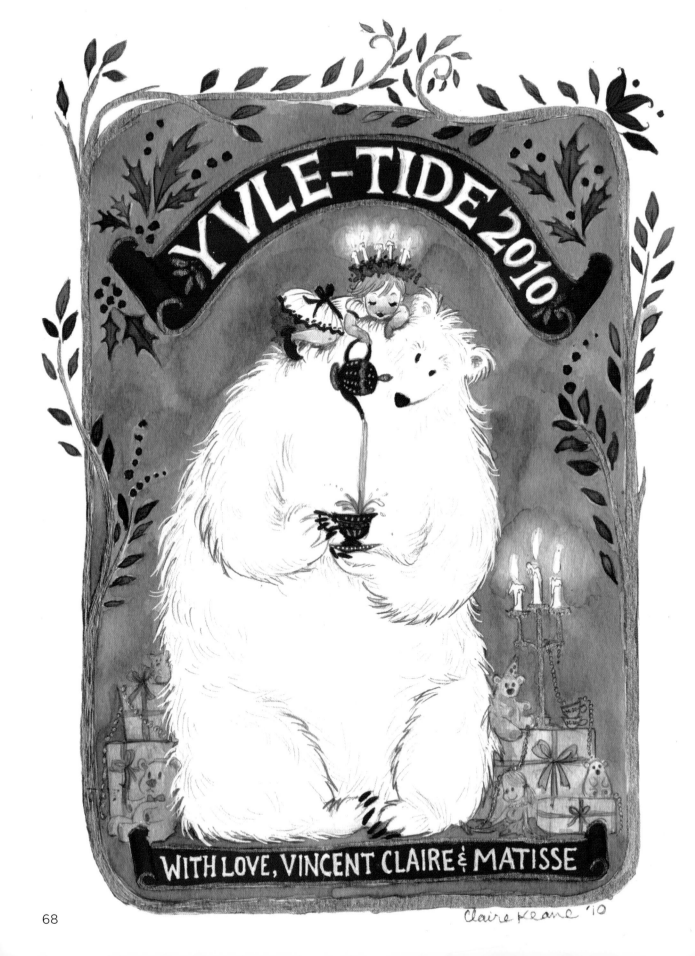

YVLE-TIDE 2010

WITH LOVE, VINCENT, CLAIRE & MATISSE

Claire Keane '10

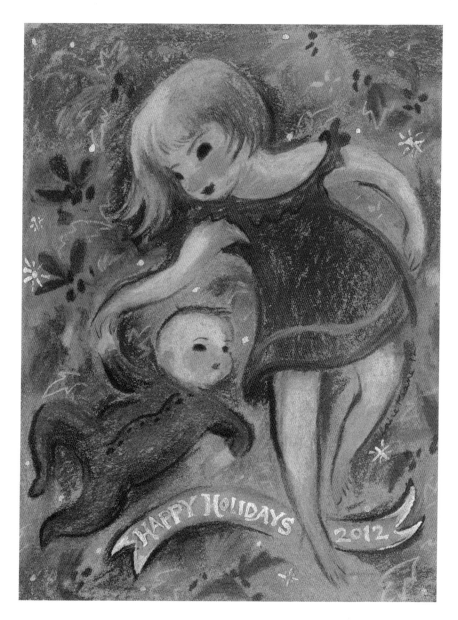

INSPIRATION

These Christmas cards were inspired by whatever milestones happened in our lives that year. In 2010, Matisse was about 20 months old and climbing onto everything, so it inspired a little visual moment of her climbing on top of a big polar bear. In 2012, I had our son, Roman. The idea of siblings content with one another was fresh in my mind and I wanted to share that with our friends and family.

I get very inspired by my kids. I find that I am creating much more for myself outside of work than I ever did before I had children. I would have never imagined that having kids alongside my full-time job could make my art better, yet it has.

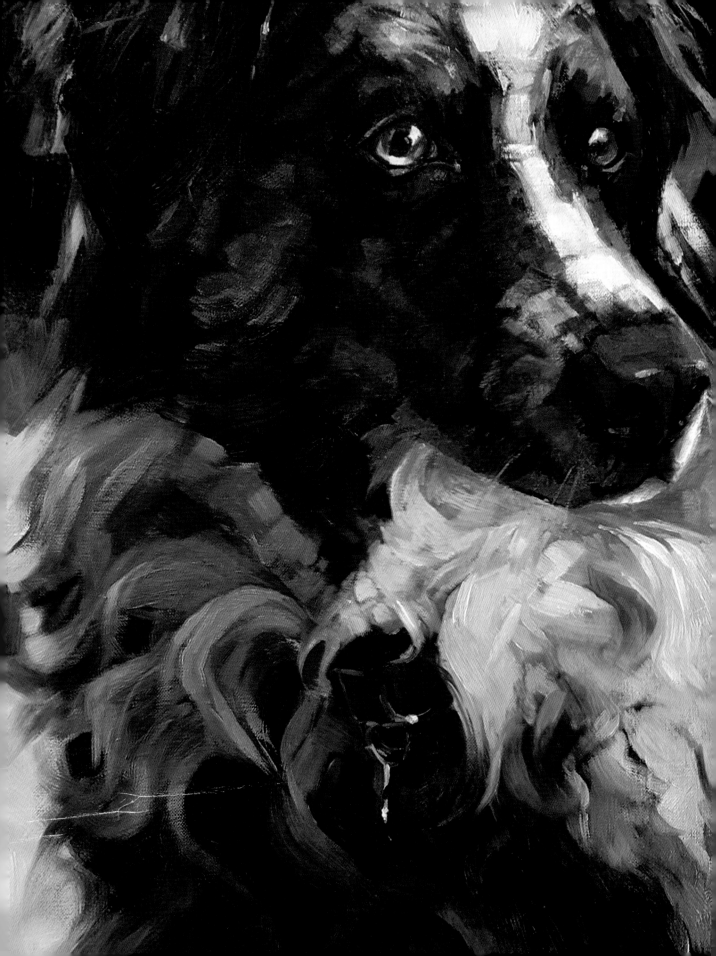

Lisa
Keene

I had an artist friend tell me once that "if you paint what you love you will do it the rest of your life." My art career up to this point had been all about work; I was either at the studio or freelancing. I loved my job; each day felt like play rather than work. It's pretty lucky to be financially compensated for something I would have done out of love anyway. However, I wasn't really doing anything purely for myself. I actually sort of forgot how.

So I took a leap and began painting the dogs and animals that I spent so much time around. It allowed me "art time" that was for no one but myself. I'd find something that inspired me to paint—a pet or other animal, a silly thing I saw, the light as it hit fur or just the personality of an animal or a moment I would like to remember. I've learned to carry my camera everywhere because animals don't sit still!

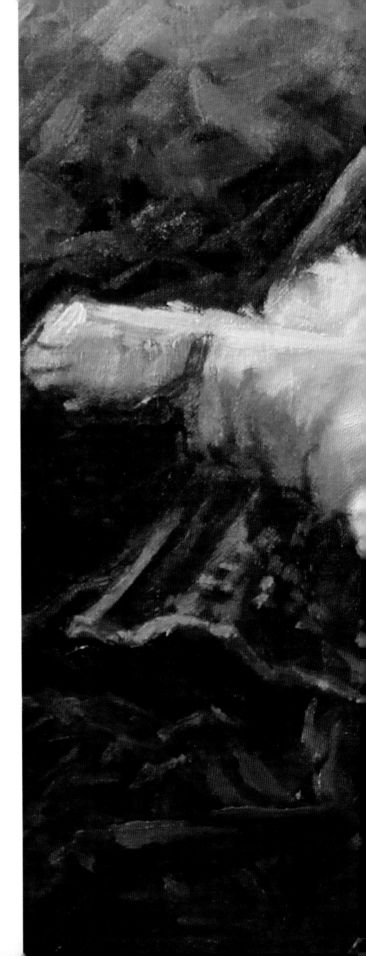

NIKI

My husband used to call this red merle Australian shepherd pup Brenda after one of my best friends. He said, "Brenda is so pretty that it's like looking at her through an old-time camera covered in gauze for one of those glamour shots." It was true; and Niki, as she is now called, has the very same ever-so-delicate mix of white and beige that seems forever out of focus.

There is nothing so charming and vulnerable as catching a pup asleep and comfortable in her innocent dreams. Niki had been playing with her brothers and sister, doing what puppies do best: ripping up plants, digging trenches of holes while searching for underground noises, and chasing each other around the yard. Exhausted, she finally fell sound asleep, and nothing could awaken her. I loved the way she looked—almost as if she were smiling in remembrance of the day's adventures!

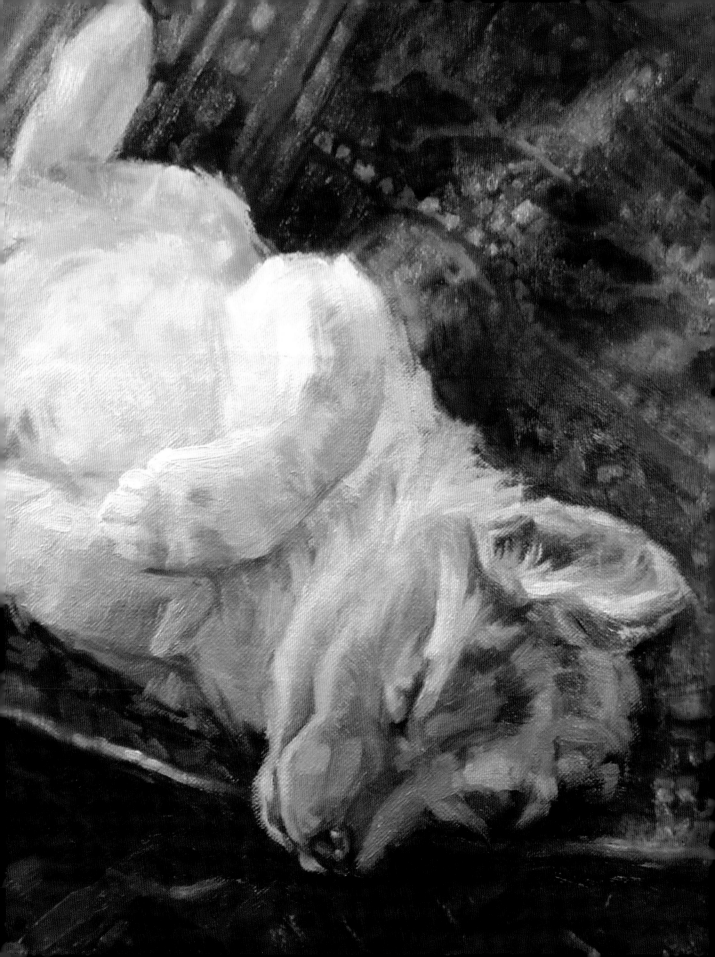

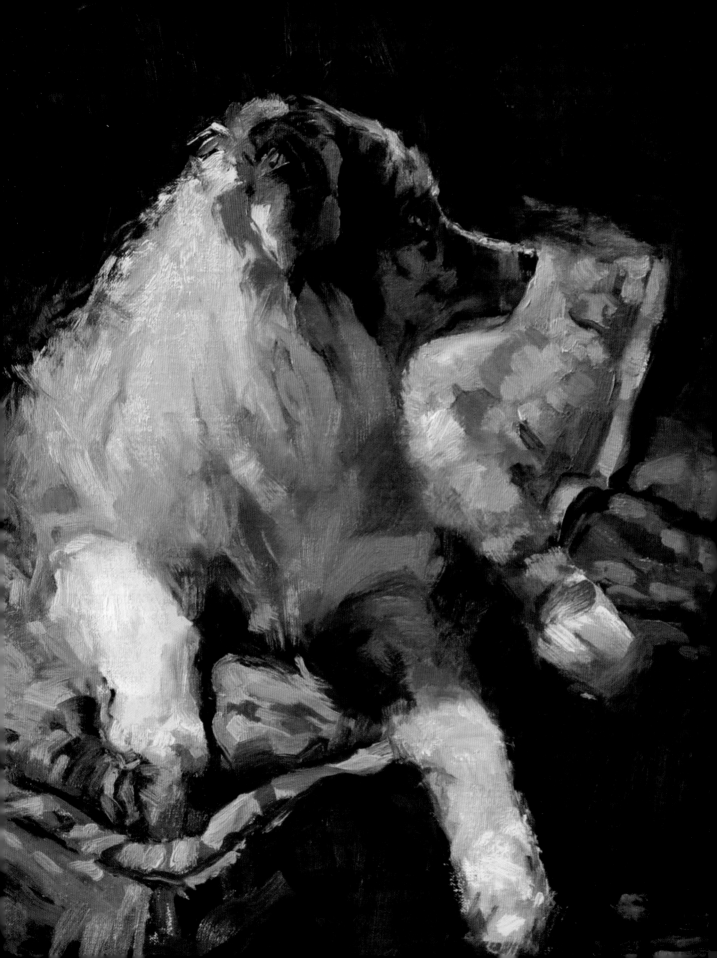

STUBS

From time to time, our lives will contrive to teach us some small truths. Stubs is one of those gifts. The little pup had a very difficult birth, and I wasn't sure she'd make it. The smallest of nine puppies, she suffered from neurological disabilities due to a lack of oxygen on her way into this world. She could suckle but lacked the strength to get a full meal, as her head wobbled too much. When she tried to crawl, she would just tip over, legs flailing in the air. For all that, nothing stopped her trying; as long as she was fighting we would too! We gave her alone time with mama dog to make sure she got enough to eat, and she began putting on weight. Day by day, she slowly improved. Born without a tail, she was quickly dubbed "Stubs," and it stuck.

We were told not to get attached to her, as she would not likely survive. The person who said that had clearly not consulted Stubs. The puppy had a will to live, and her indomitable spirit pushed her through the handicaps she endured. It was a little hard to watch her learn to walk and run because at the slightest touch, over she would go!

Stubs was 3 or 4 months old at the time of the painting. She is now 8 years old, and you would never know how tenuous her odds were. She is one of the smartest dogs I have ever known. She is so happy and cheerful, and her sense of play and enthusiasm for everything she does are truly inspirational.

From her I have learned that life is a gift—no matter what—to be enjoyed in every moment to the fullest, regardless of the obstacles before us.

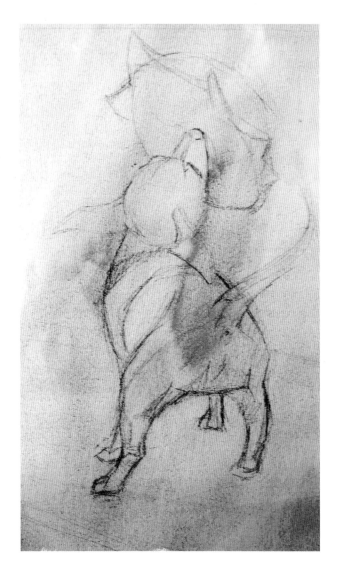

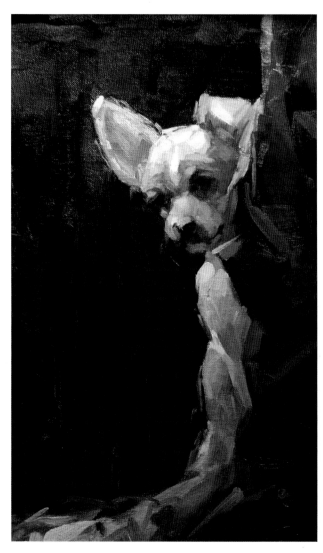

LULU

This little gal was in a cage meant for a rabbit with her two siblings. We knew that their socialization had been minimal and dutifully took them all out and played with each one. As they all squirmed, shook, and shivered from our contact, this one would not stop wagging her tail and trying to kiss our faces. Her tail was going so fast you had a hard time seeing it.

She picked us and begged us to take her. When we got home, she ran, on wobbly little legs, to explore her new surroundings. Every few seconds, she would run to hide behind my husband or myself, looking out at her new world with curiosity and wonder. Again and again she'd go running out from safety to see it all with more time alone, gaining confidence in her new surroundings. She has not stopped since.

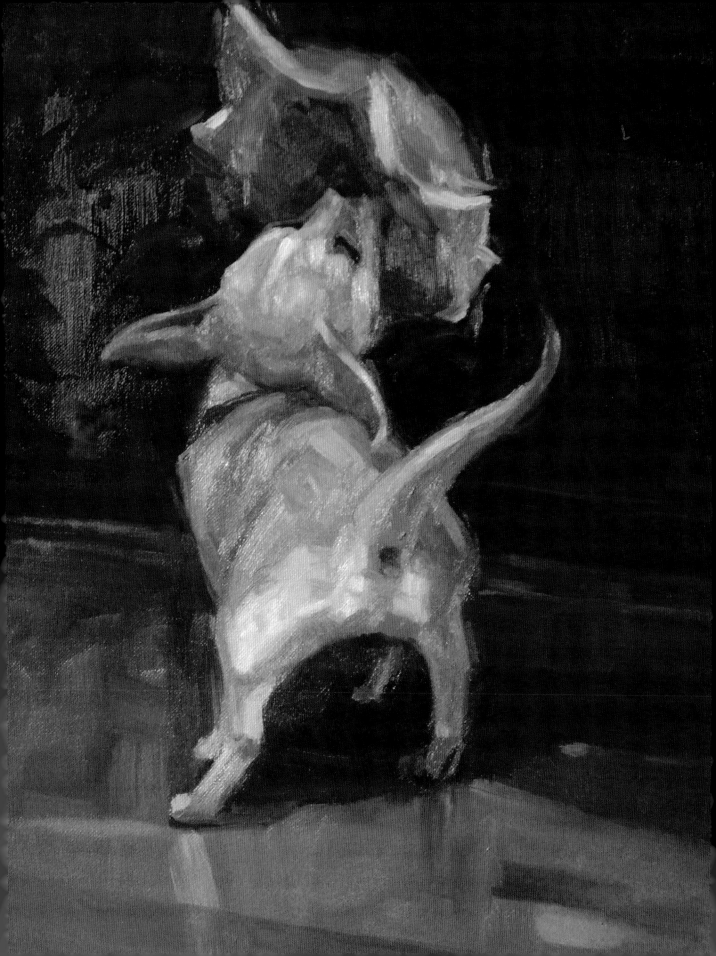

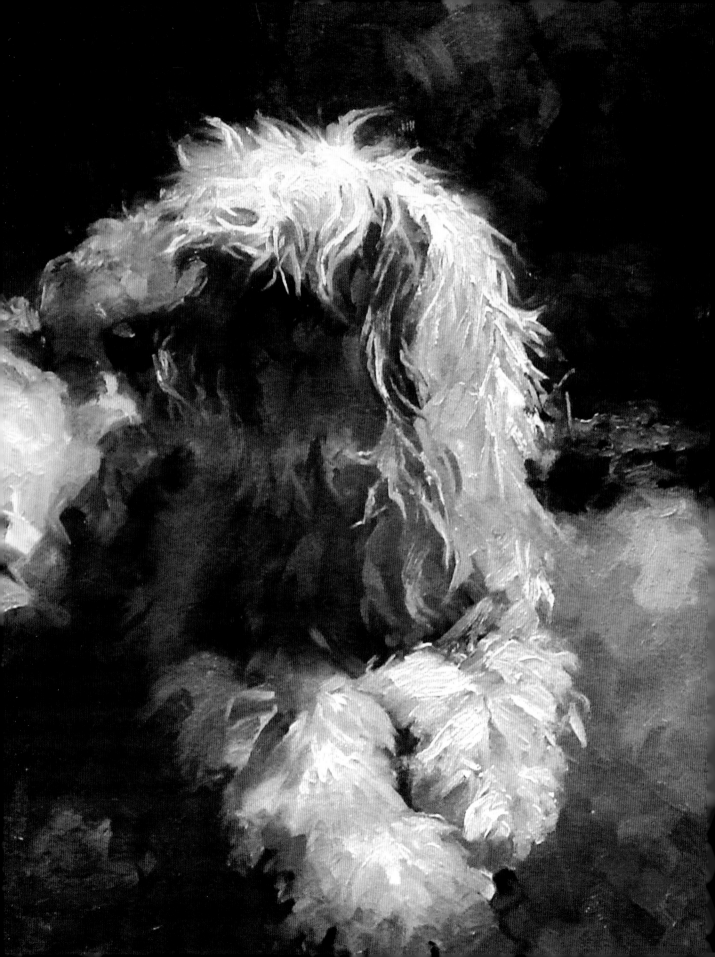

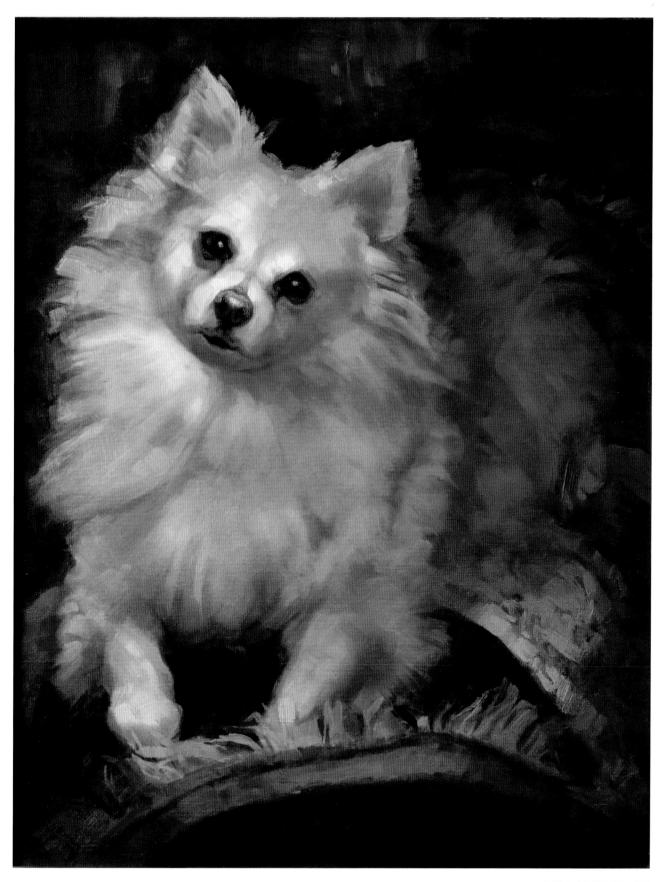

MONTABELLO

We had recently lost a rescued Chihuahua that had become a friend to our own Chi, Monty. We called this one Hansen, named after the dam where he was found. The little guy was old and near death when we discovered him. So when he left us 5 years later, we imagined him ancient. Monty, now alone and withdrawn, needed a new friend. On a suggestion we made our way to the desert to see some little Chis and found Lulu.

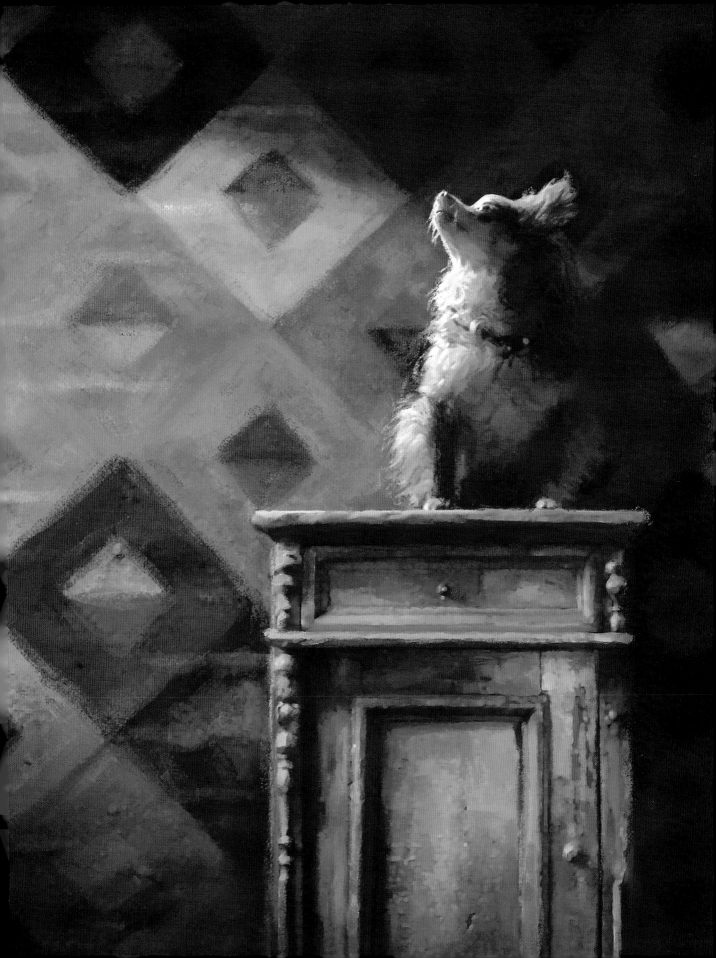

PONGO

I boarded my horses at a ranch called Bella Vista, and every evening I would see the owners, Carlo and Evelyn, survey the ranch from their golf cart. It was uncommon for me to see their dog Pongo unless he was on some errand. However, he invariably made an appearance if carrots were being sorted! He would patiently stand by, waiting for someone to grant him the choice piece of a vegetable. Then, off he would go to relish the prize.

After Evelyn passed away, I could always count on Pongo to be in Evelyn's seat to patrol the ranch with Carlo. There they were, side by side, two elderly gentlemen seeking each other's company and making their rounds of the ranch at sunset.

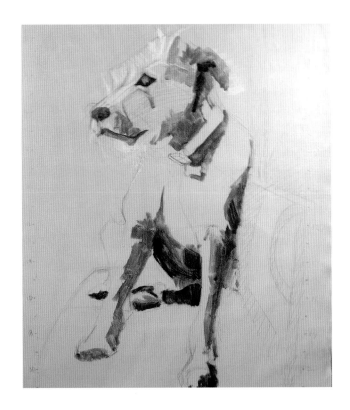

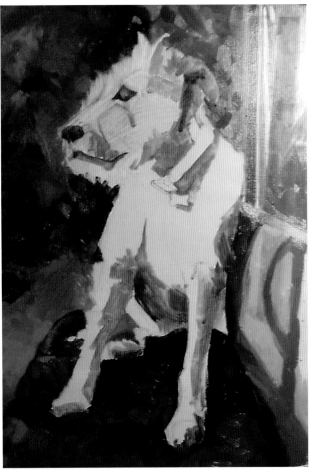

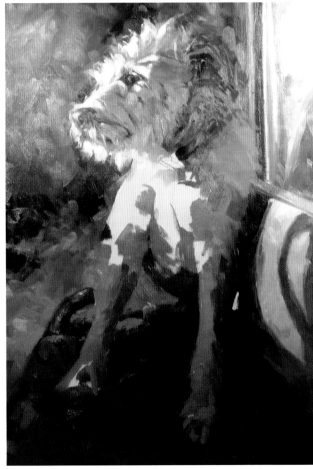

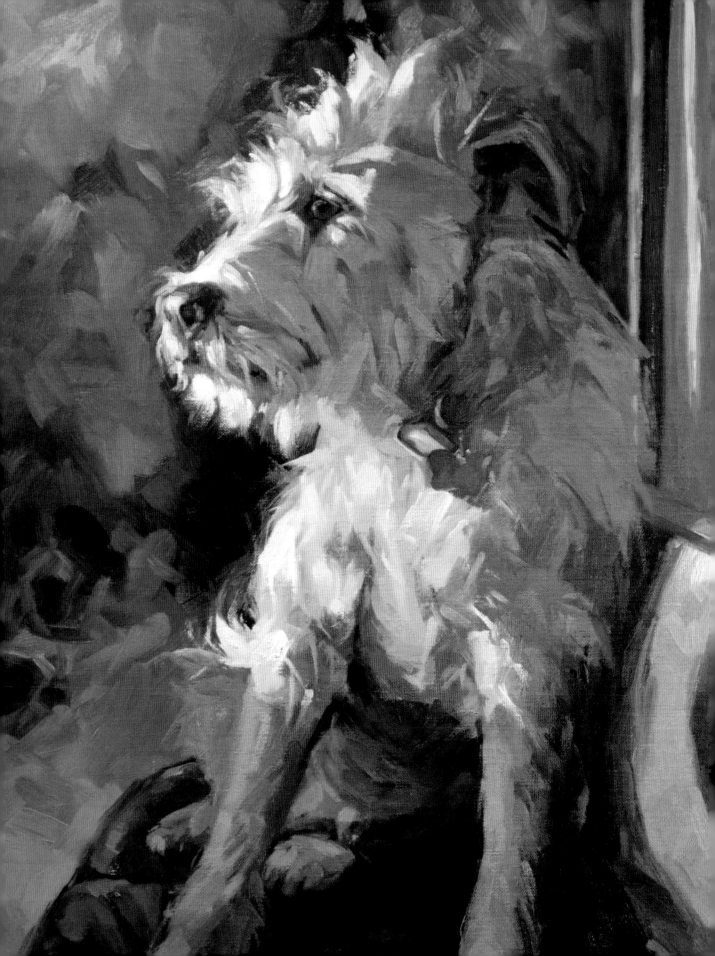

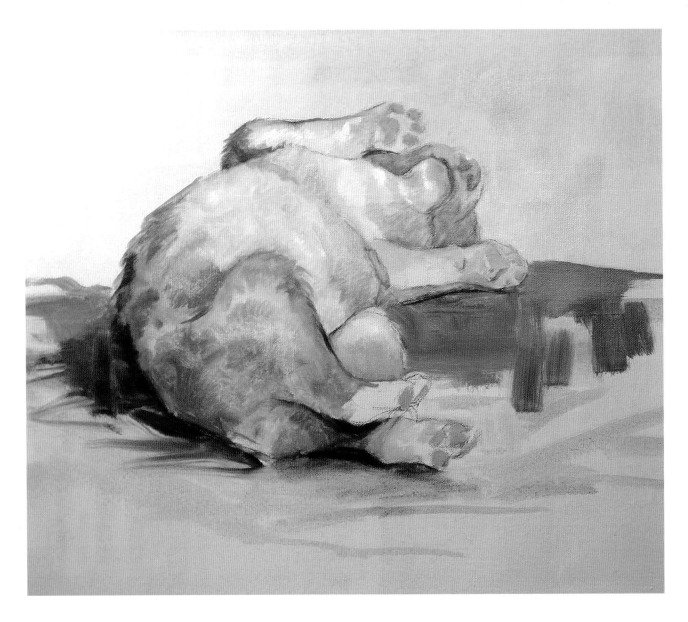

SHERIFF

Sheriff is the most affectionate dog I have ever owned. He has the uncanny ability to just melt into every nook and cranny wherever he is snuggling. He loves chairs . . . and he'd probably be content to just relax in upholstered comfort forever! On this particular day, it was raining. Sheriff welcomed the opportunity to stay warm and dry.

I had no intention of keeping this pup; you just can't keep them all. However, when his eyes opened and he had his first moment of true focus as a newborn, he rocked back on his little rump, stuck his chest out, and stared straight into my eyes. The connection was so strong and deliberate, as if he were saying, "Oh! So *that* is what you look like." In that split second, he looked at me with such devotion and attachment that I knew he was not going anywhere.

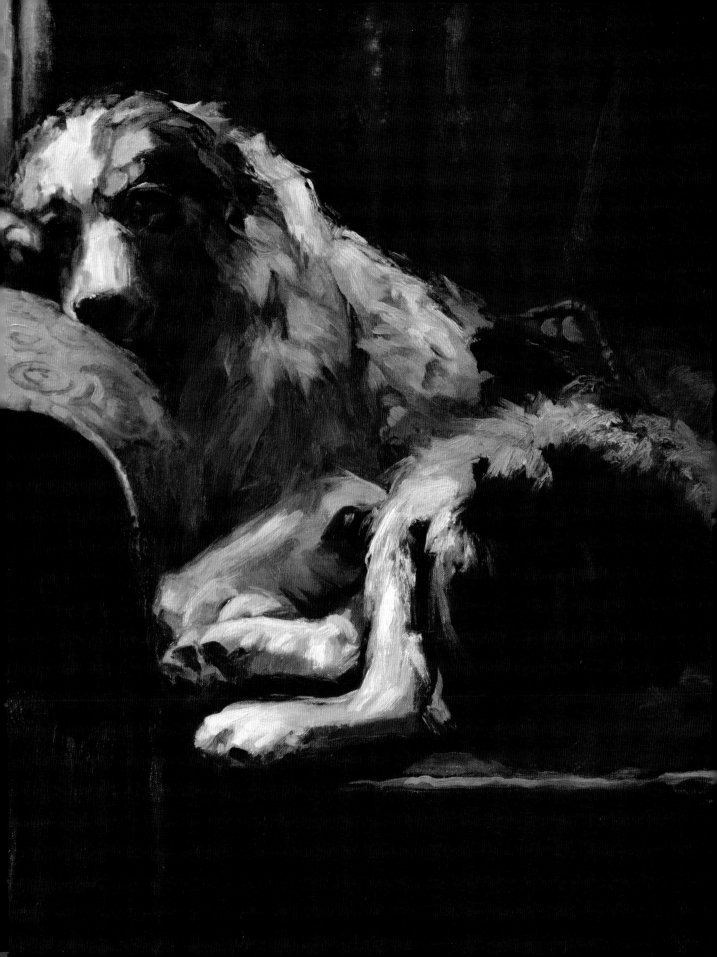

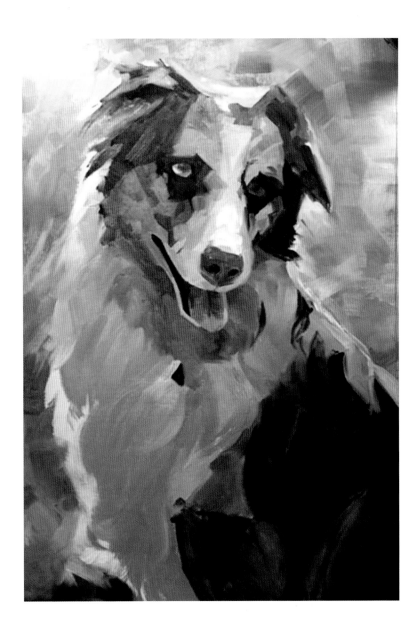

ELLIE

I try to document my paintings as I go so I can later review them and learn from my success or mistakes. I used my phone for the block-in, so forgive the unprofessional photo. I try to lay in the darkest darks and the lightest lights first. That way I know how to play my middle ranges. I have found that if I don't do that, I can wander around in my value structures and make huge mistakes in the way I want my paintings to read. Add to this the spots and color activity of Australian shepherds, and it quickly can turn into chaos. Ellie was particularly challenging, for she was a beautifully marked blue merle with loads of spots, and all the colors of her surroundings reflected back into her white.

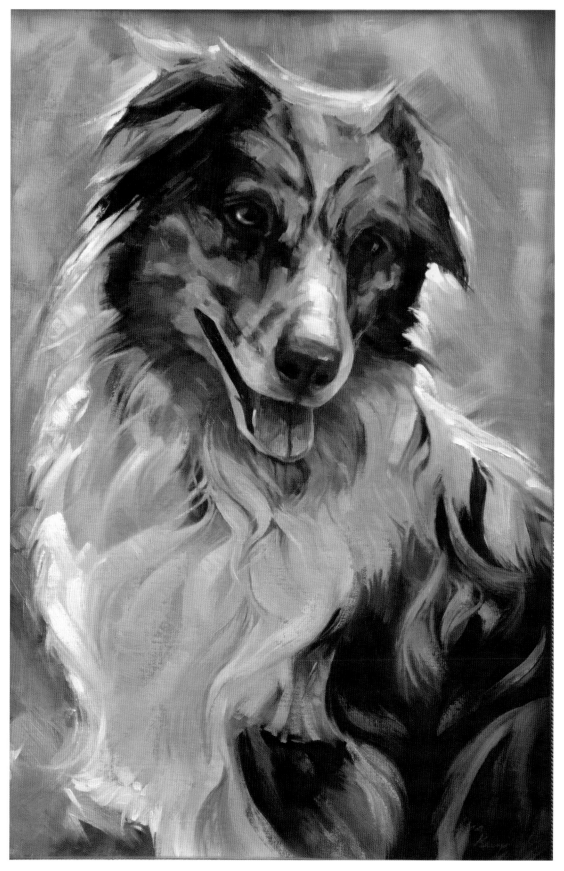

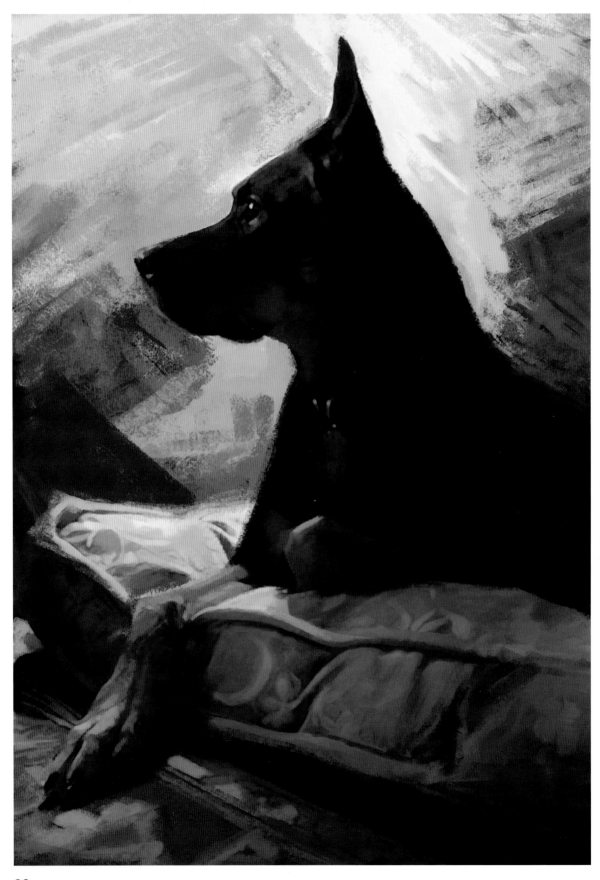

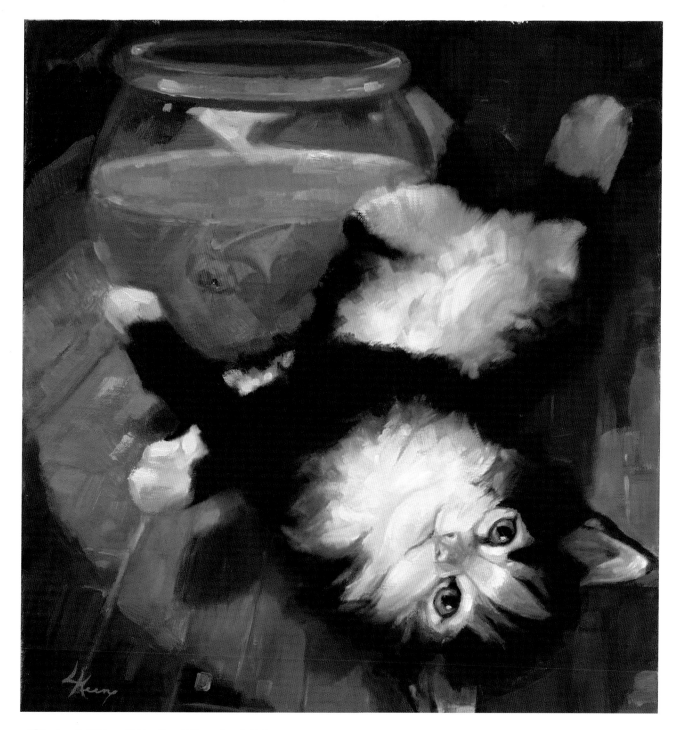

ONE EAR UP

The other ear goes to the side. It doesn't stop him from hearing his car coming home from blocks away. Buddy came to us running from 4th of July fireworks. He was exhausted and cut up from running through sage brush; at his height, everything was at stomach level and sharp. He literally ran into my arms as I stood at the edge of my driveway. He has a soft heart—and it's a good thing too at 110 pounds.

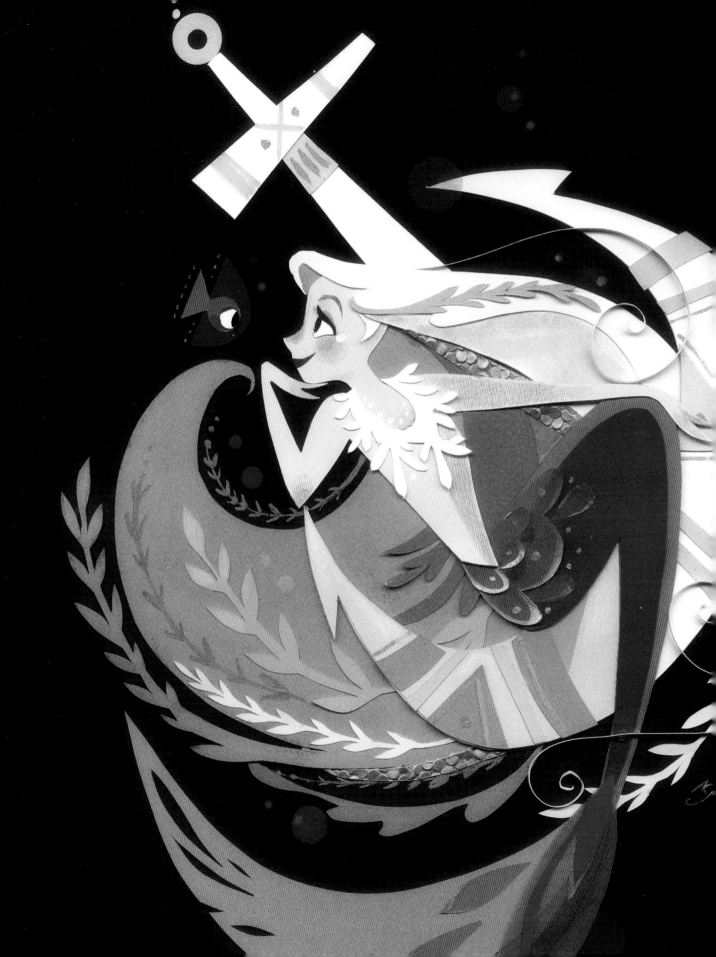

Brittney
Lee

I have always been an artist at heart, but becoming a professional artist was a goal that I planned out and worked toward from the first time I could hold a crayon. The discovery that I could express myself through cut paper, however, was a complete accident. I came across a piece of artwork that intrigued and inspired me and subsequently found an opportunity to utilize the technique. I jumped at the chance to learn something new. With the reckless abandon of a kid who definitely runs with scissors, I fell head over heels in love and have been looking for new ways to explore the medium ever since.

In my personal work, I constantly strive to find that balance that is struck when three parts meticulous planning meet one part the space and freedom required for happy accidents to emerge. Turns out that (for me, at least) the thrill of the unknown is half of the fun of creating.

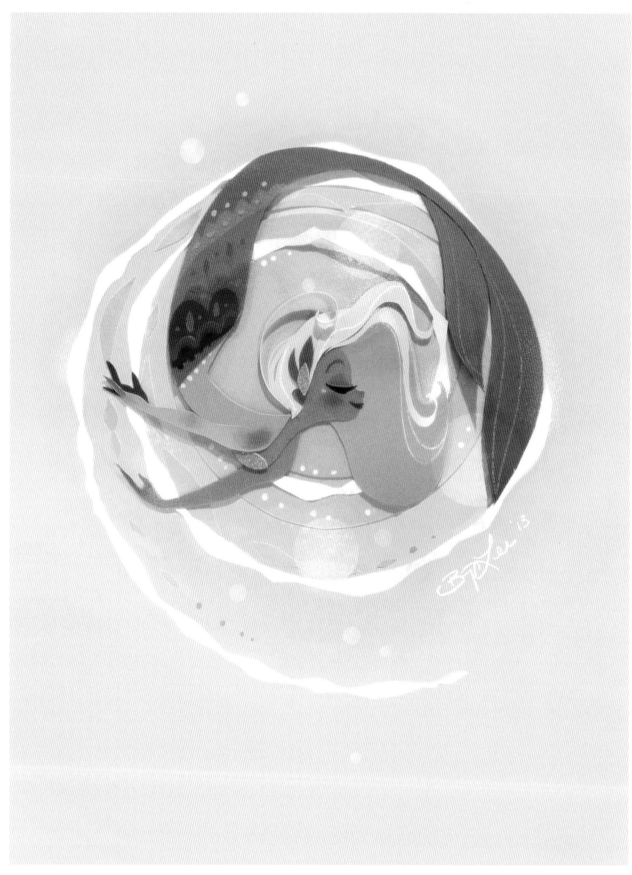

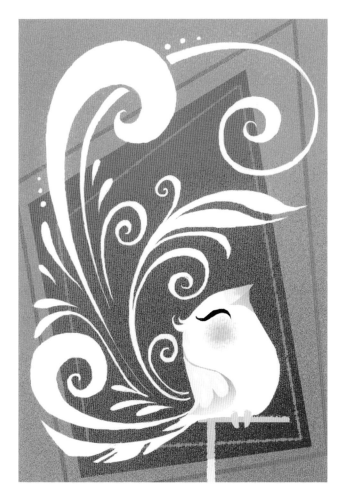

MOVEMENT

I am fascinated by movement—it's what initially attracted me to the art of animation. Rhythm is just as much a part of my palette as any paint color or paper stock. Heck, I still occasionally bust out a time step from my tap-dancing days (when no one is looking) just to get the creative juices flowing. If I need that kick of kinetic energy to get myself going, I certainly want it to

be felt in my final artwork. Maybe that is part of the reason why I gravitate toward certain subjects. Due to the nature of water, mermaids must be in a constant state of motion, right? Right. It's science. I imagine them as underwater ballerinas, and would love nothing more than to bring this fleeting moment I might capture to life.

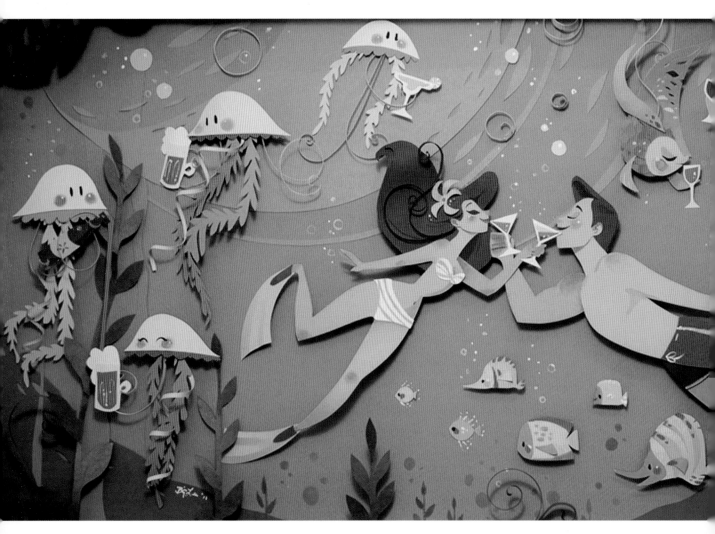

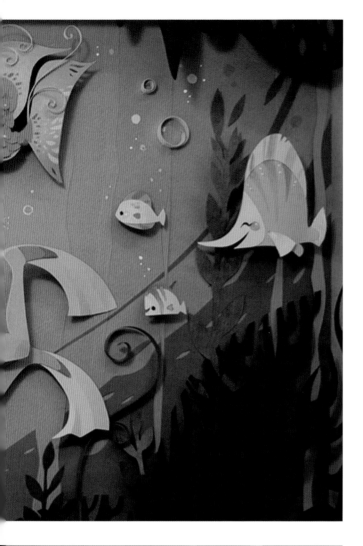

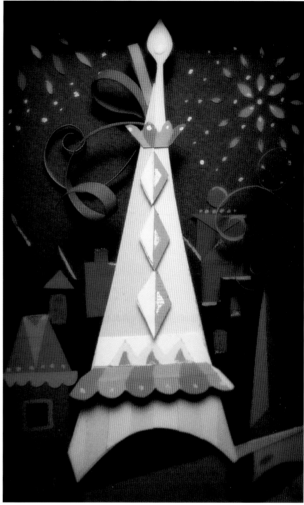

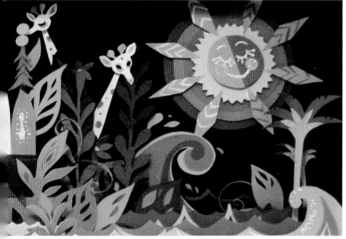

HAPPY PLACE

Personal-work time is my playtime. While I labor away at my cutting table, I often daydream about the distant, fantastical places I would like to visit, people I would like to meet, and cafés where we could become friends over espressos and chocolate. It is the time when I can take all of the random thoughts that I have throughout the week and mold them into something that is all my own. My studio is my happy place, my corner of the world where I have the power to make these dreams come true. I find so much joy in realizing absurd ideas. Jellyfish sharing some beers? I'll drink to that.

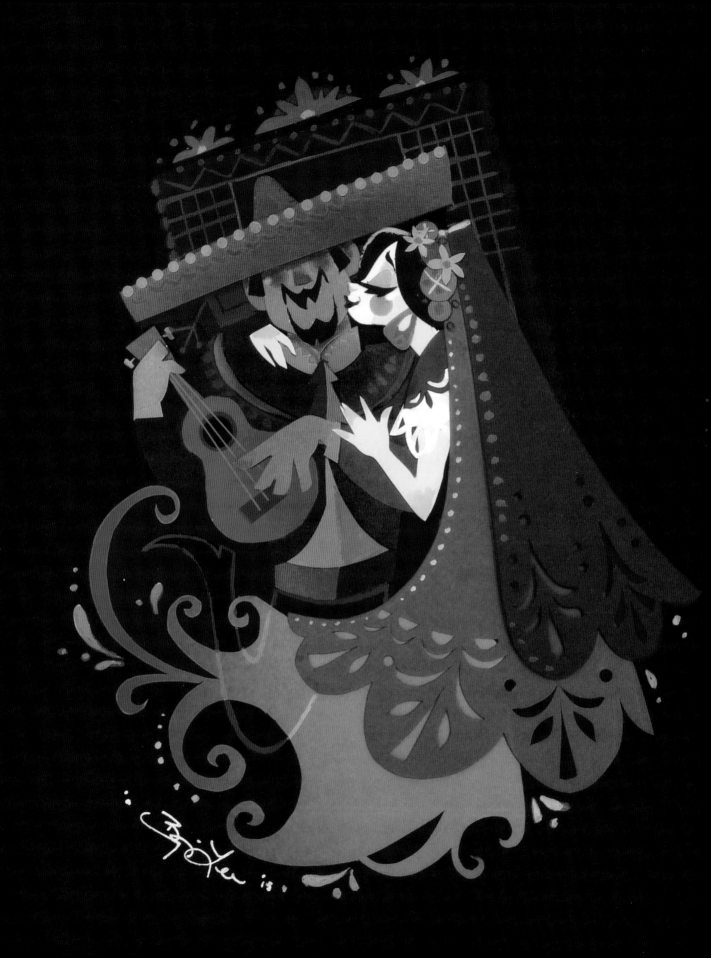

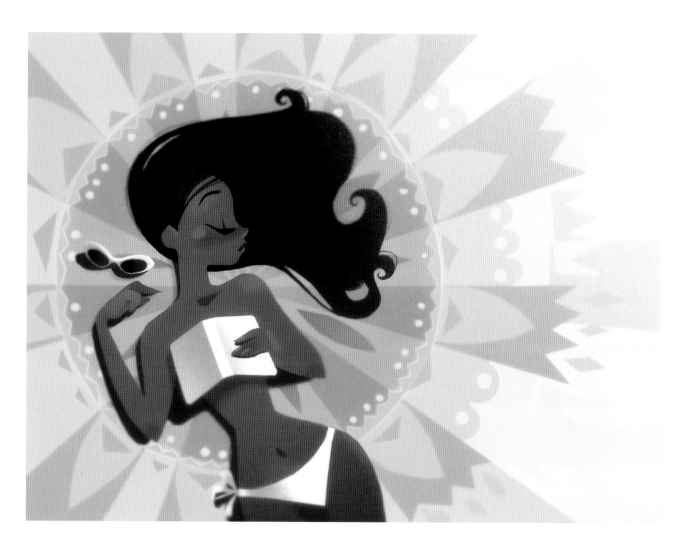

MEXICO

I am a terrible photographer. It's a real problem. It is not even that I take bad photographs, really, but that I just have a general aversion to taking them at all. Don't get me wrong—I love the idea of photography. Whenever I am at an event or visiting a place that would warrant capturing images, I show up with multiple cameras in hand. And take zero pictures. I tell myself that it is because I would rather be present to experience the actual event or place, but really, I think I am just lazy and/or distracted by margaritas.

My hope, though, is that I do soak up enough inspiration from the places I visit to create new work with new influences. I recently visited Mexico, and the designs and colors I saw while there were so unique and beautiful that I couldn't wait to come home to try to infuse my work with a new flavor. That flavor may or may not taste something like tequila, but I will let you be the judge of that.

LEGENDARY BEAUTIES

Creating artwork is a bit like acting out a role on stage. You get to interpret personalities in your own way. For a minute (or hours or days or weeks), you can become someone or something else.

I definitely felt this to be the case when Lorelay and I worked on our Legendary Beauties show together. We met and discussed all of the possible subjects that we could think of for the show, and then started choosing which female figures we wanted to depict. We each chose personalities who intrigued us, and in the end I think we definitely added a bit of ourselves to each woman we portrayed.

The muses were really enjoyable to work on because, to me, each of them represents one piece of a whole personality. Sometimes I'm overwhelmed, sometimes I'm in control, and sometimes I just want to dance—but I am always the sum of these parts.

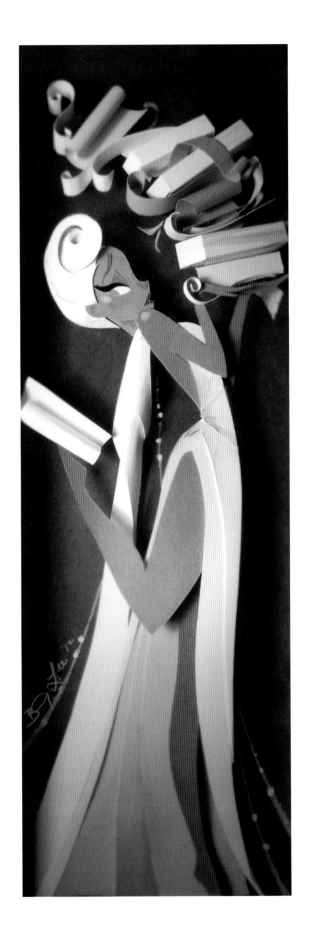

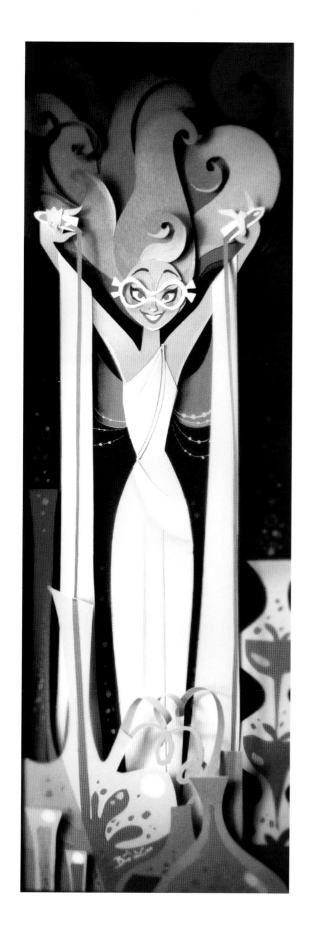
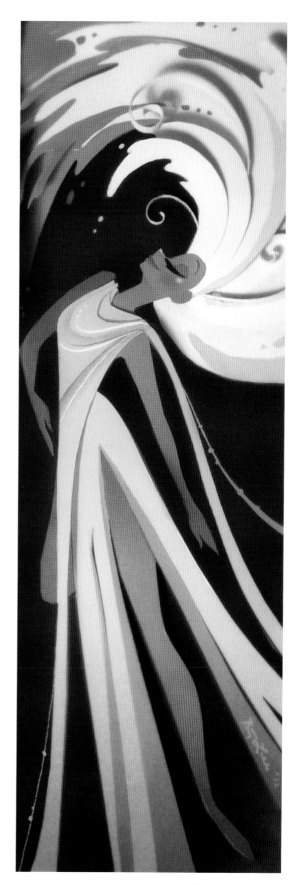

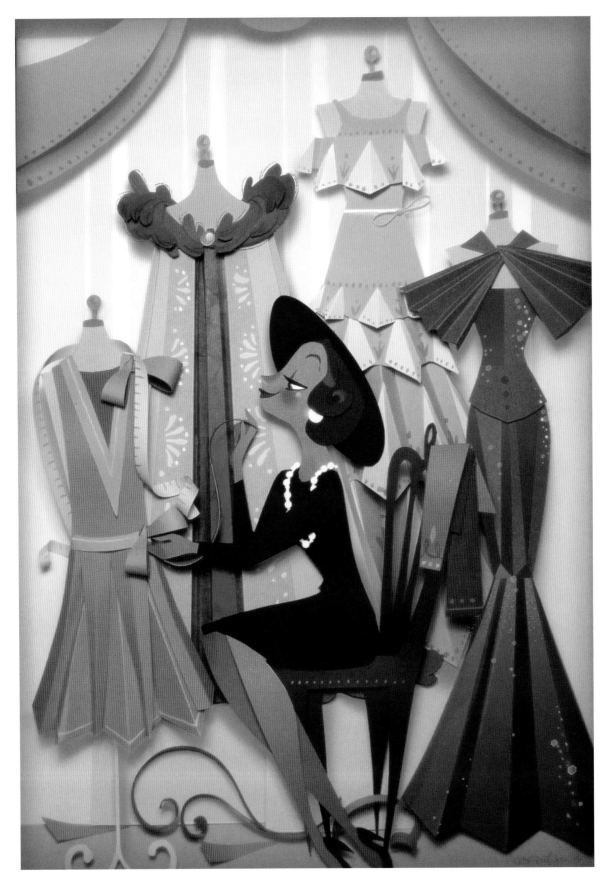

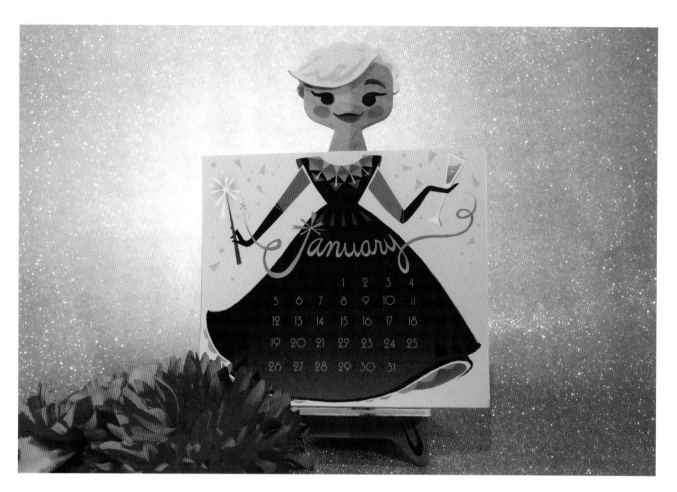

2014

CALENDAR GIRL

LIMITED EDITION DESK CALENDAR

TO THE NINES

I cannot help but be influenced by the work I'm doing at my day job. You would think that years spent working on something day in and day out would put a bad taste in your mouth, but that really is not true at all. It sparks a passion that, in my case, I would love to explore further.

After a couple of years working with costume designs, I now find myself gravitating toward artwork of the wearable kind. I can't sew a lick, but goshdarn it I can cut and hot-glue a pretty fabulous dress together.

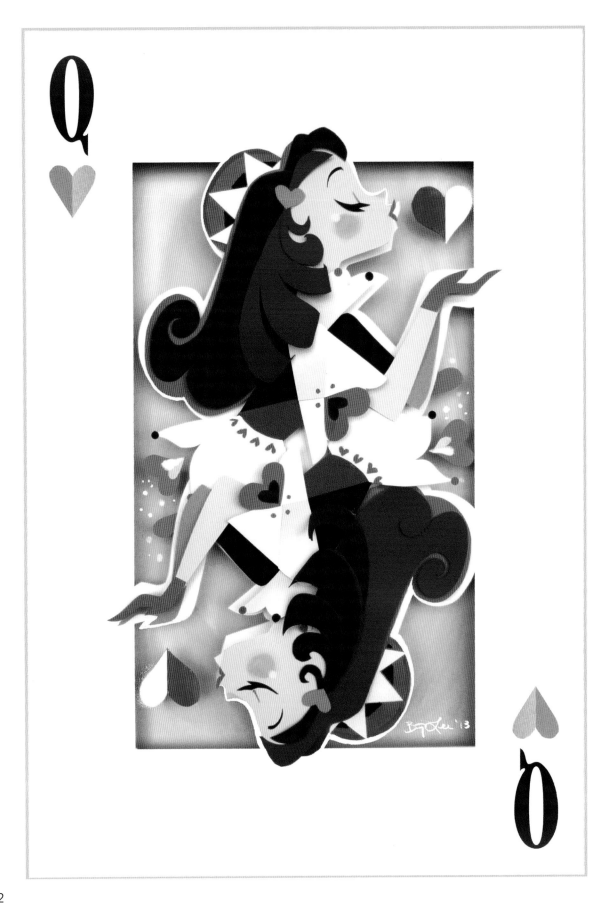

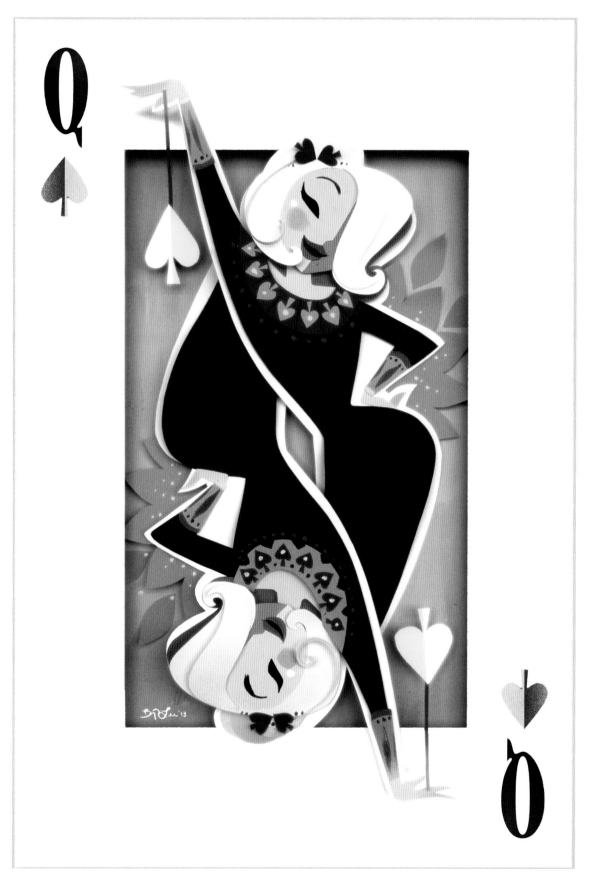

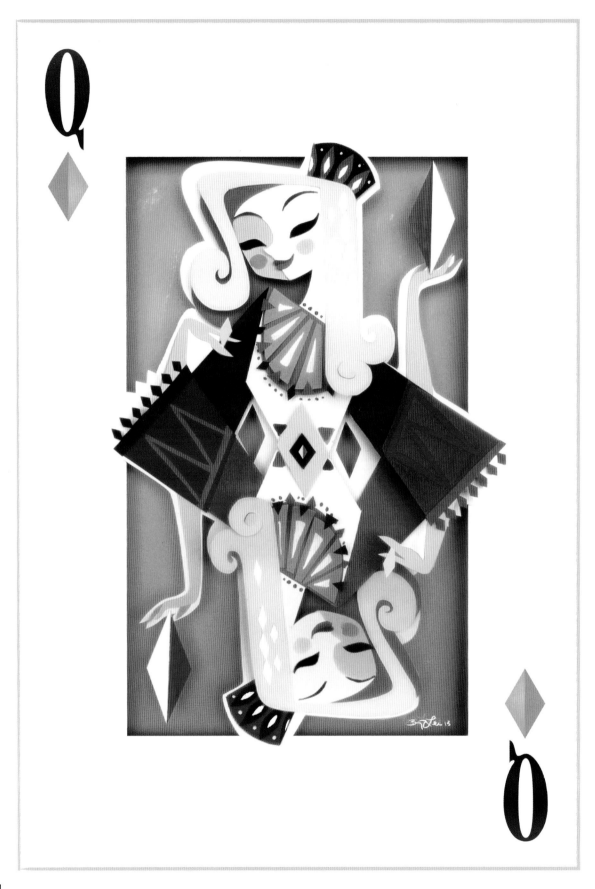

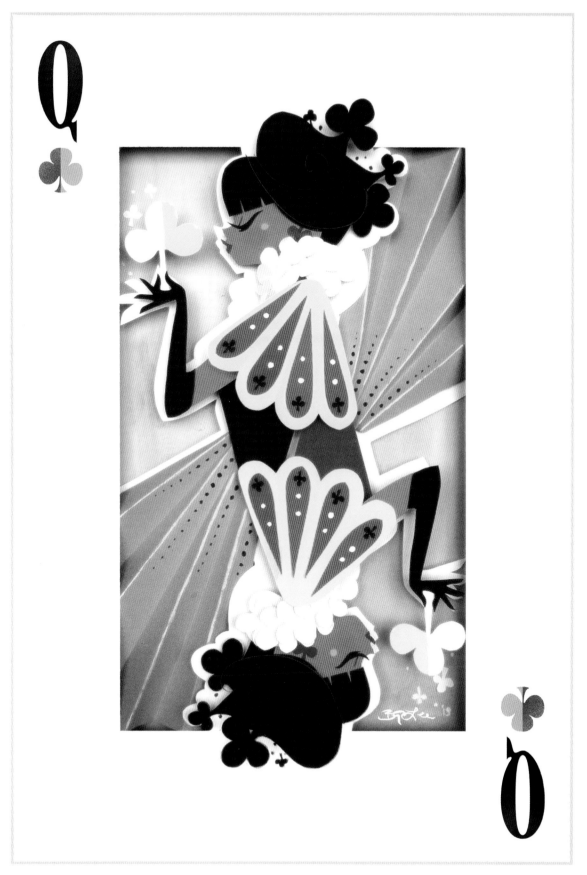

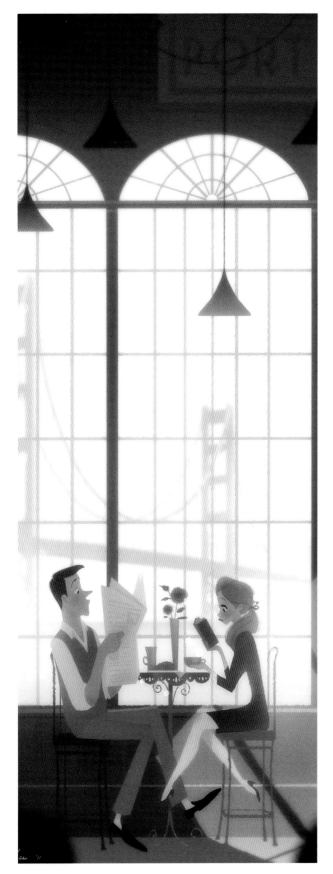
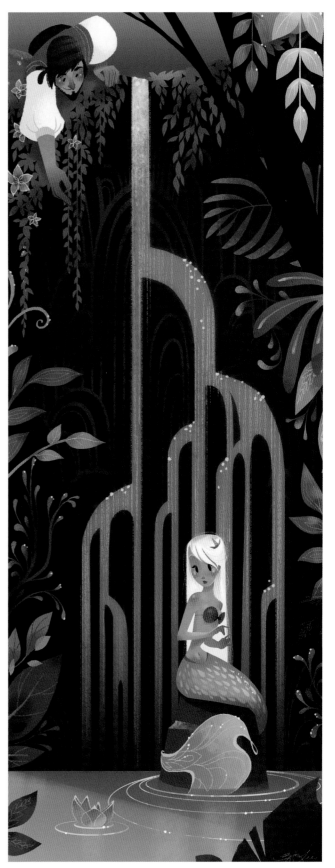

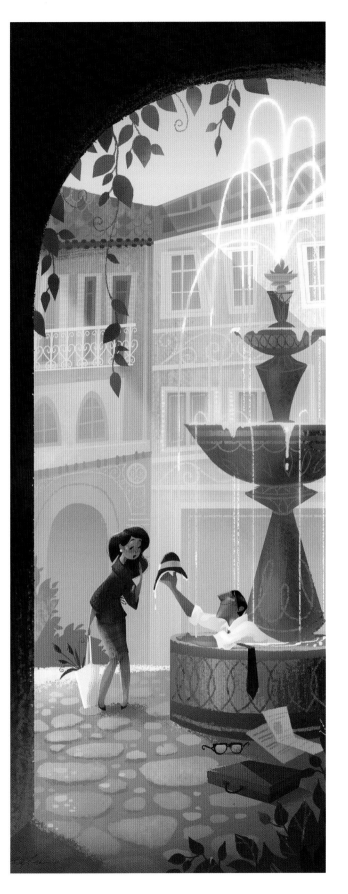

BOY MEETS GIRL

No matter what the medium or subject matter, every artist included in this book shares a common thread: we are storytellers. We strive to share our messages not with the use of our voices or the written word, but with imagery.

The boy-meets-girl scenario has endless possibilities, and I thought it would be fun to explore a few such stories in illustration form. The meeting is the point where two stories collide: the story of how the two people came to be in that place at the same time and then the story of everything that happens after that. It is a moment full of potential, which makes it a lot of fun to bring to life!

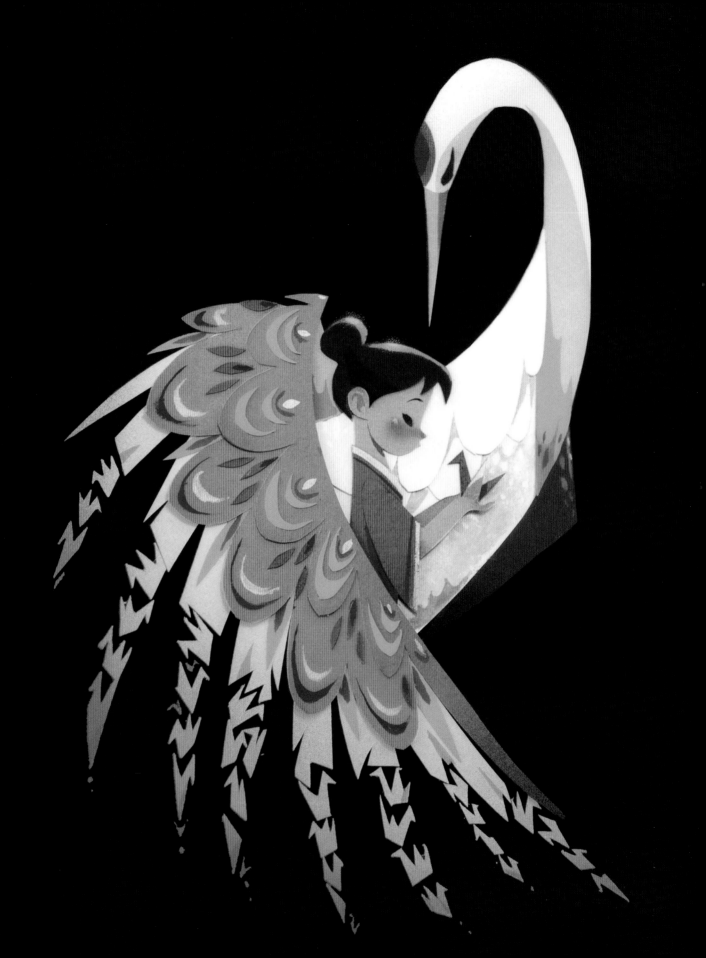

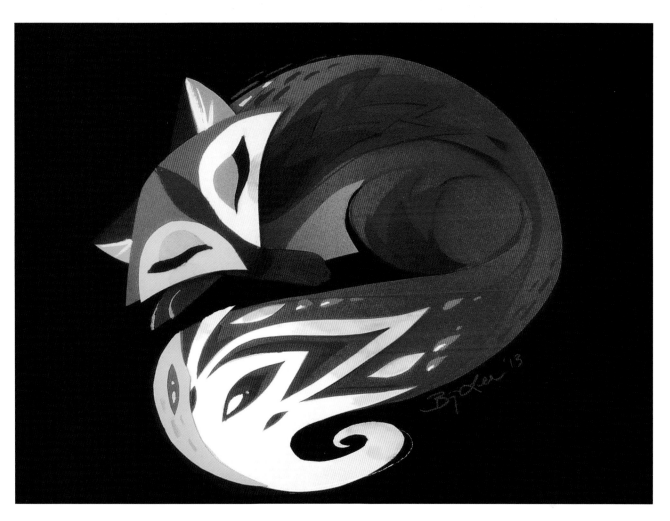

JOY

If there is any consistent goal that I have for my personal work, it would be this: to keep having fun while always pushing myself to try something new. It is joyful work that we get to do, and I am thankful every day for that.

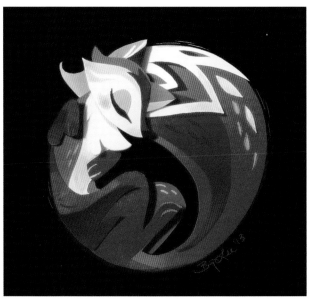

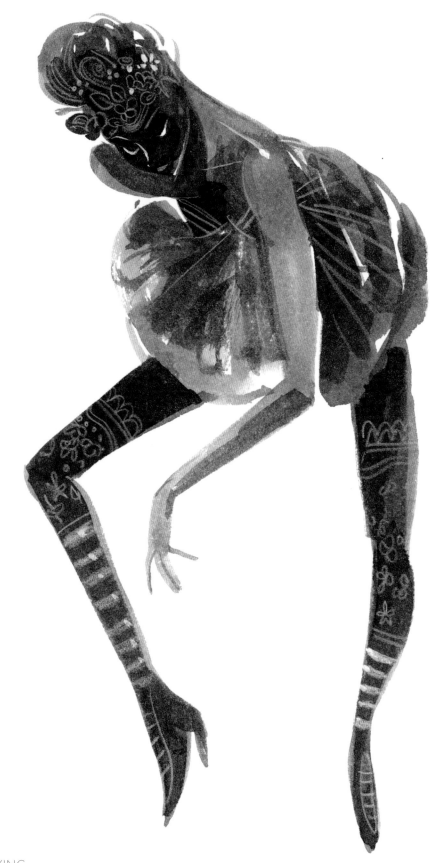

Victoria Ying

Some people look at my personal work and have a hard time categorizing me as an artist. I'm not especially consistent in what I do because I'm interested in too many things! In a given day, I may find a great mobile at a museum and want to make something like that, or maybe I'll see a great ink-wash piece online and want to try that. I've always been into artistic experimentation, and personal work has been an amazing outlet for that. There are happy accidents all the time when you use physical media and it teaches you to think differently about the work that you do professionally.

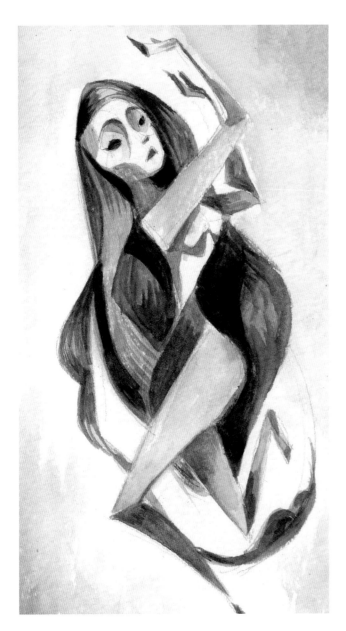

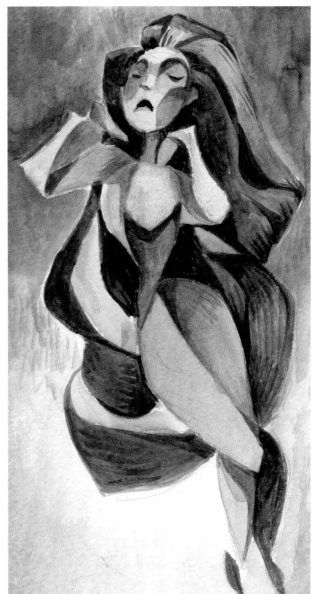

CUBISM

Some of my favorite artists were abstract cubists like Picasso and Matisse. Alas, working in a 3-D setting where realism and the ability for objects to turn in space are requirements does not always allow for that sort of inspiration, but doing these for myself was a real treat. I made these on a flight from Los Angeles to Sydney where I only had a tiny watercolor pad to work on, so it forced me to use very limited colors and to build up my values slowly.

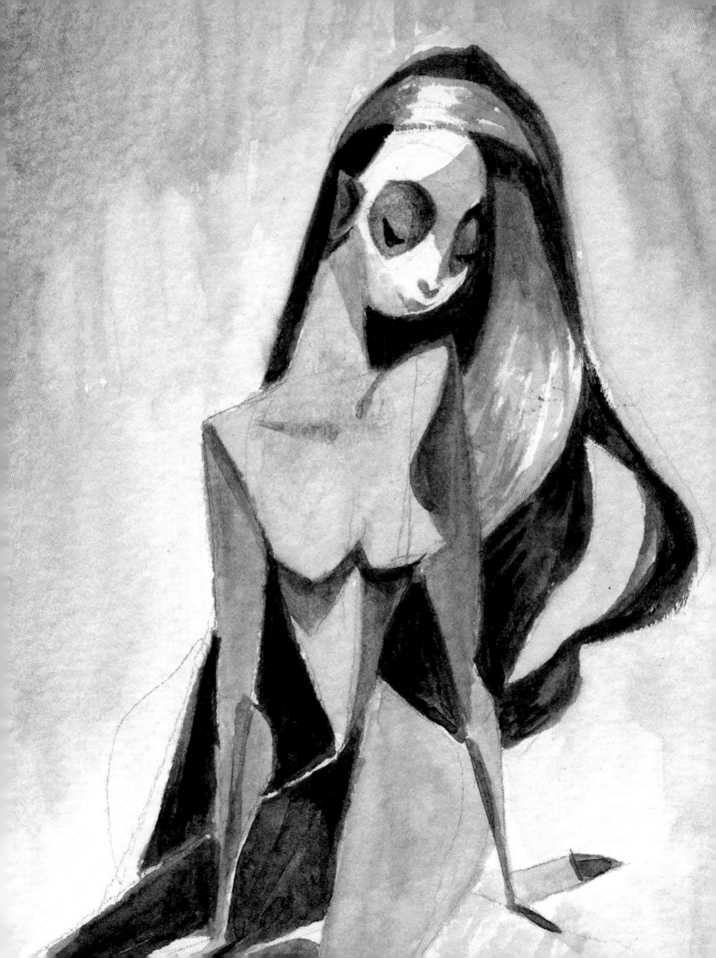

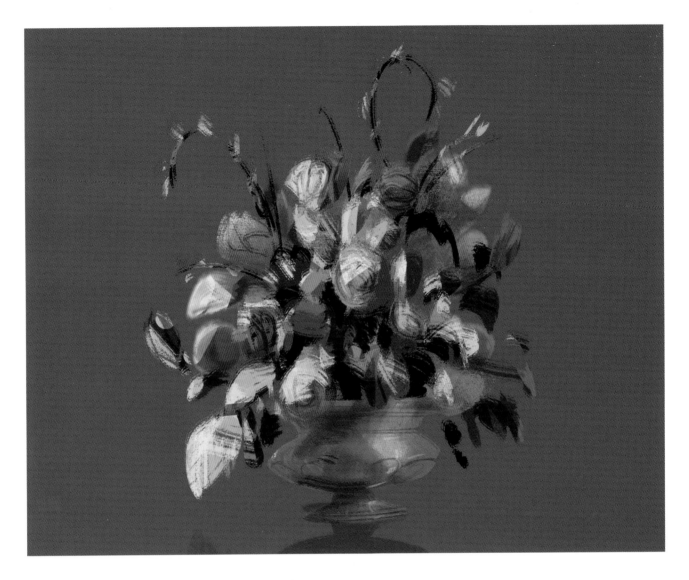

FLOWERS

Sometimes, work can be frustrating and experiments can go awry; it can leave me feeling like a failure. When that happens, I like to just use Photoshop to paint flower arrangements. It's a weird habit, I suppose, but I think it helps me by being a simple thing to paint that I know I can accomplish.

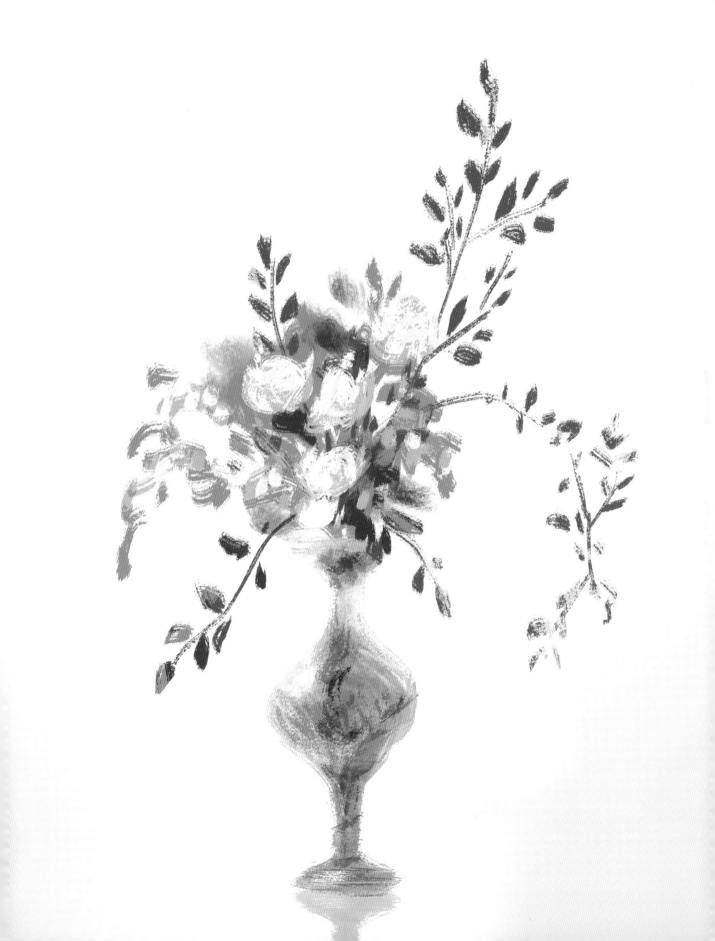

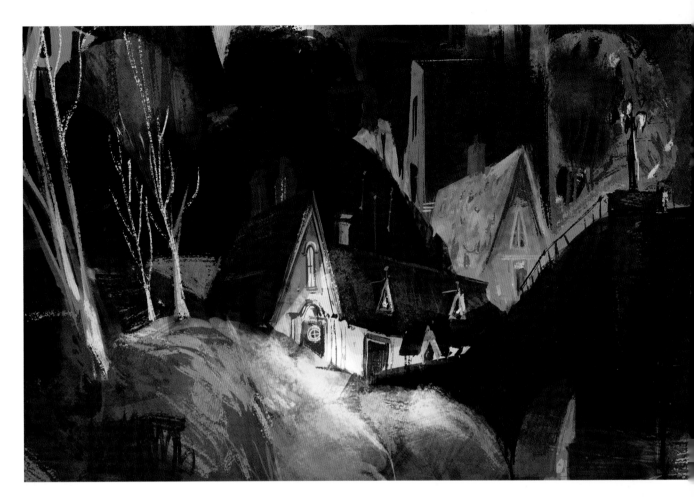

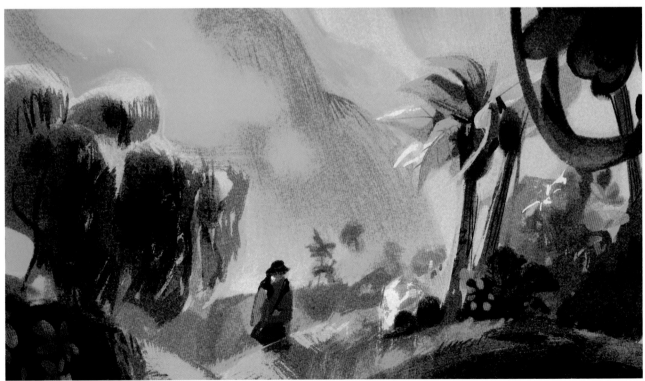

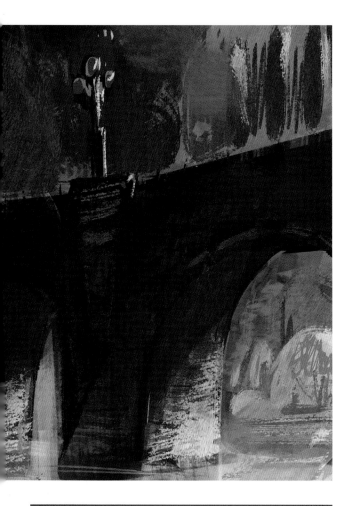

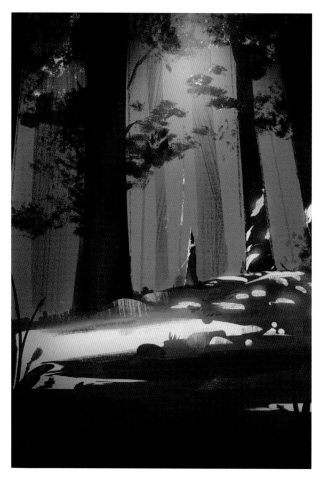

NATURE

Natural environments have always been one of my favorite things to paint. Sometimes the projects you work on or the assignments you are given can put a lot of time between you and the things you most enjoy painting, so in my spare time I like to do sketches of natural places. These were all done in Photoshop.

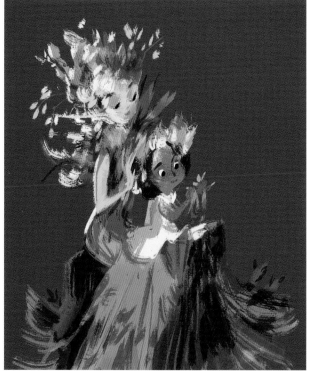

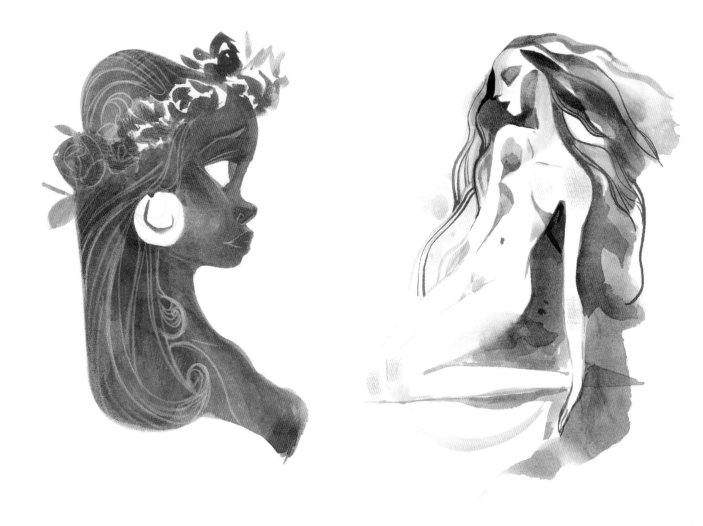

INK

My love of media is always encouraging me to try new things. For this page, I created a series of figures using black ink. I loved how active the line was and how natural and textural the paper and ink were. After I finished with the initial black and white, I brought them into Photoshop and worked in color with textured brushes. There are some things that real media can't do as well as Photoshop, but luckily I'm not a purist, so I'm willing to mix and match.

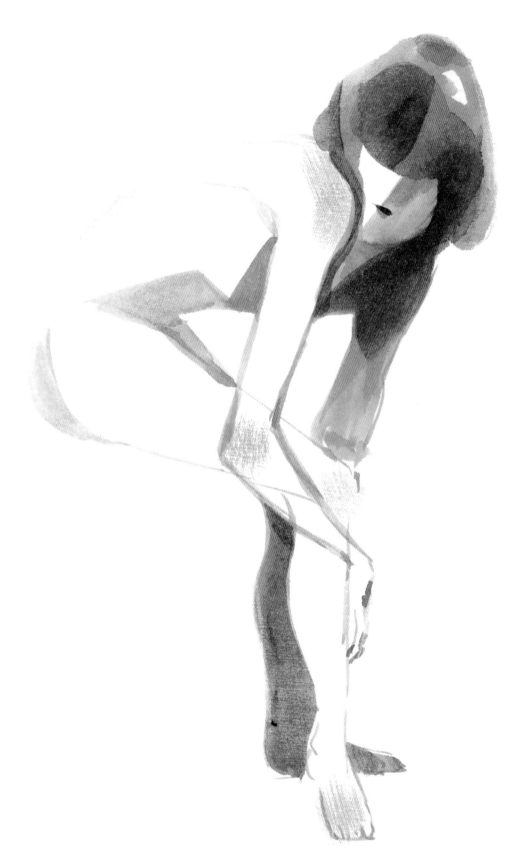

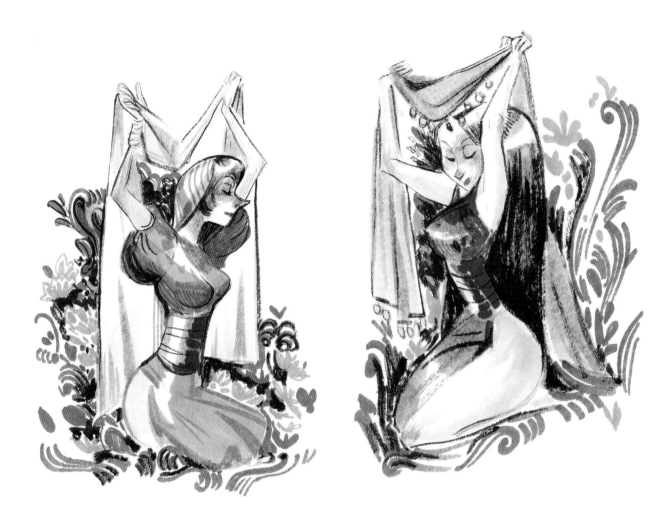

MIX

Sometimes I can only do work with whatever I have on hand. The top two pieces were done during jury duty, where all I had were some markers and an ink brush. I tried to conservatively use the colors I had available to create as pleasing an illustration as possible. On the opposite page, I created an ink drawing. I used a white colored pencil to get a very fine, detailed line on the interior of the silhouette.

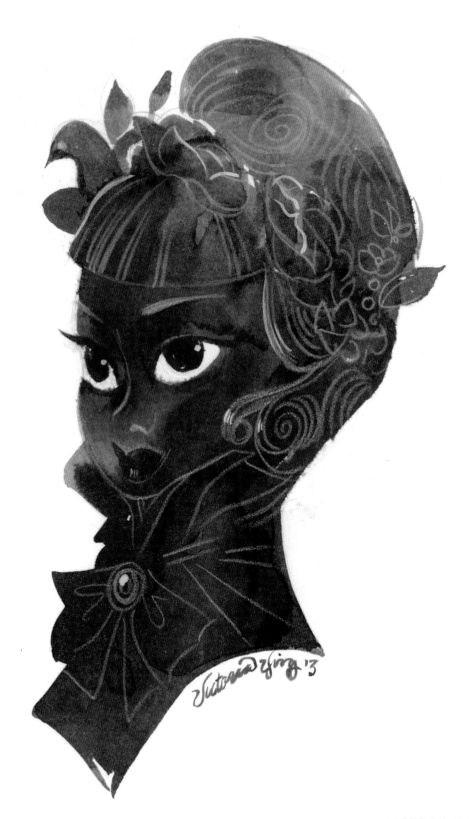

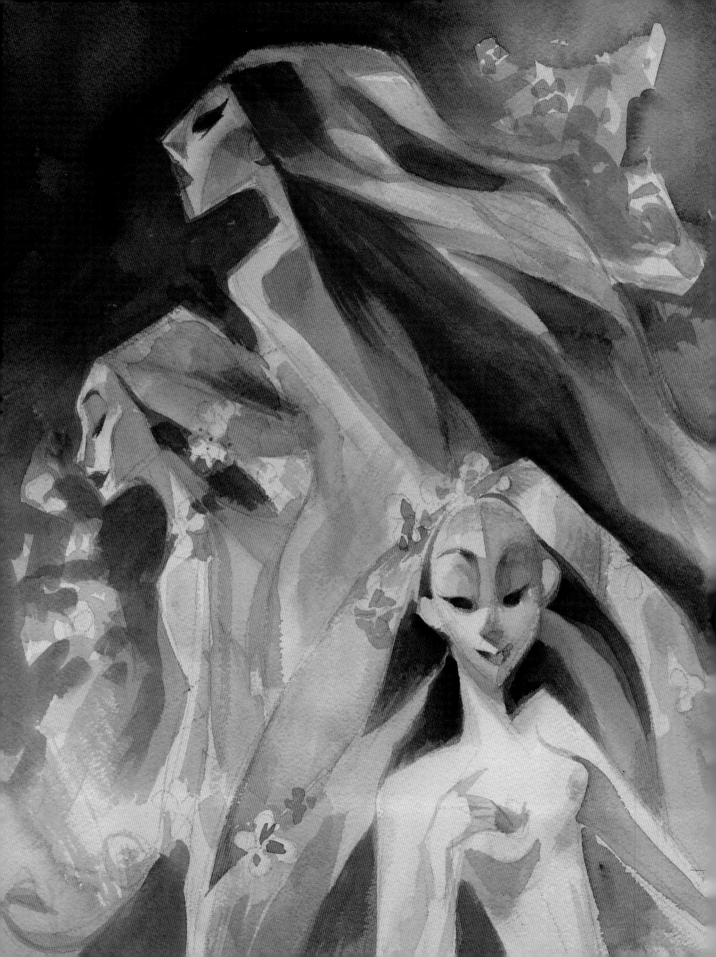

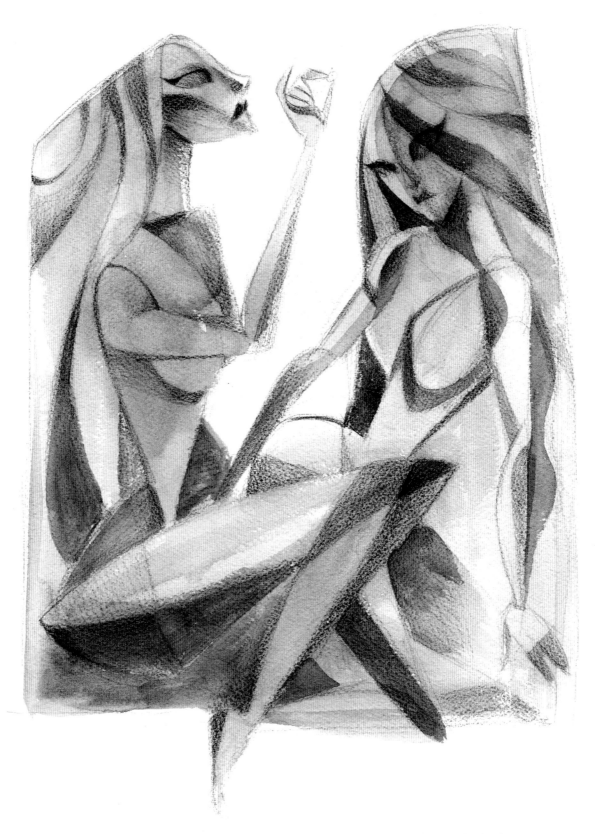

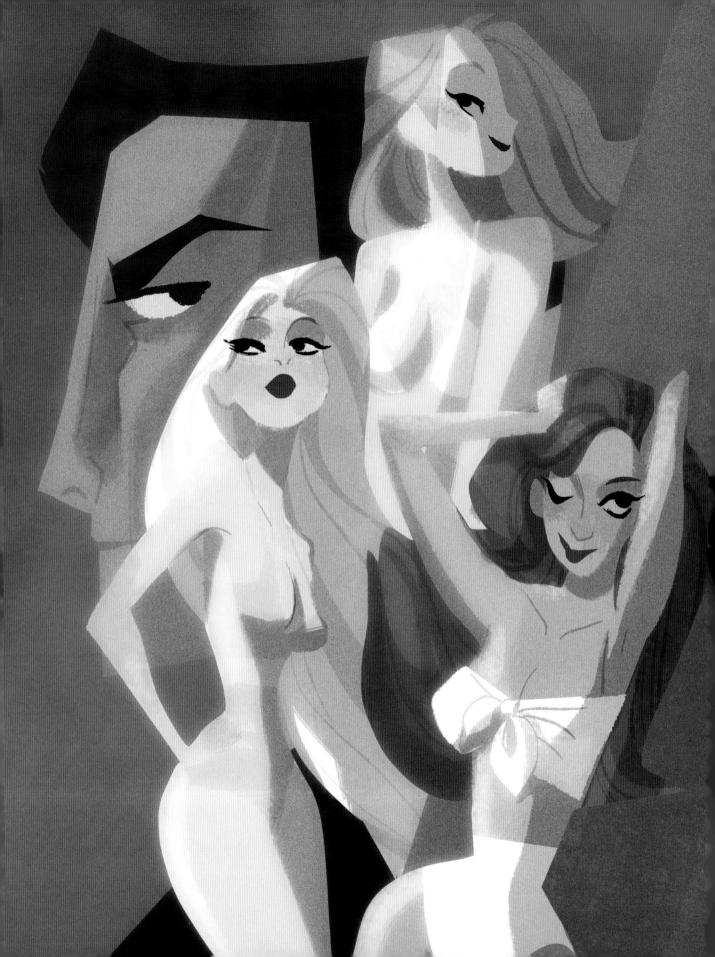

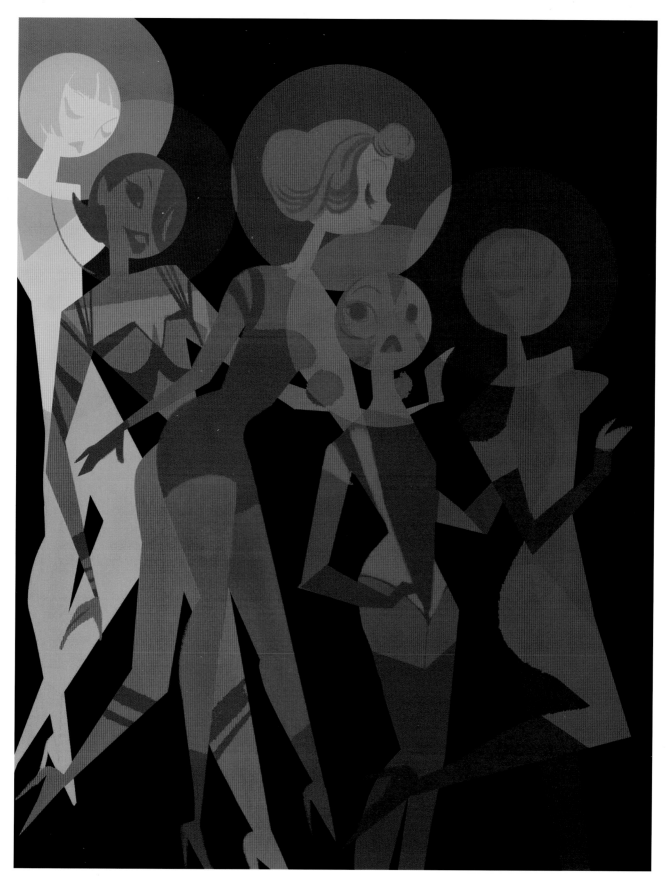

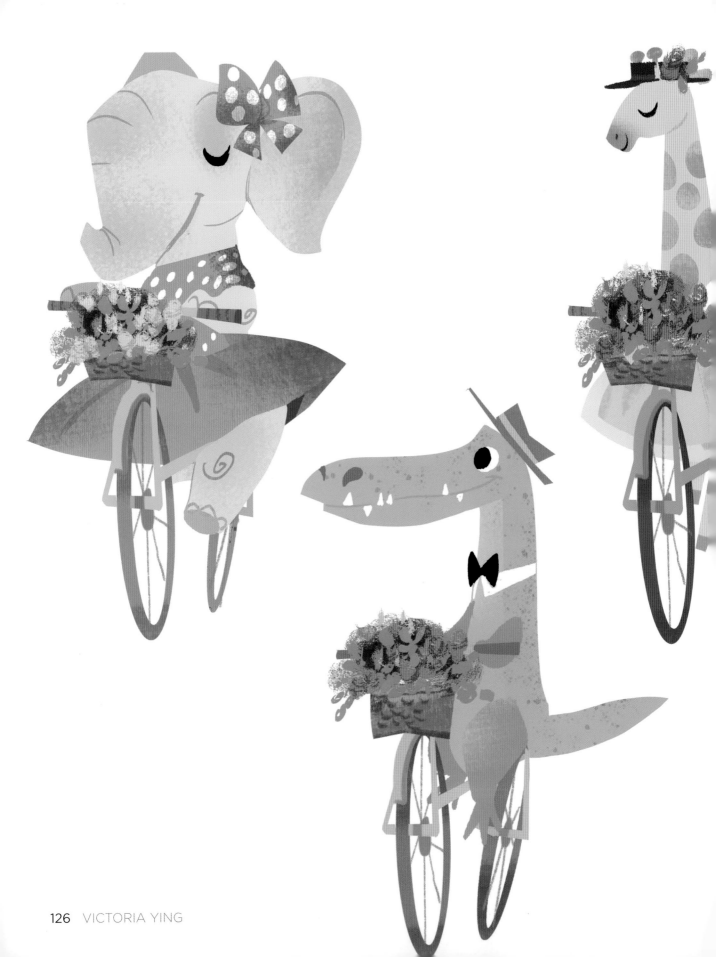

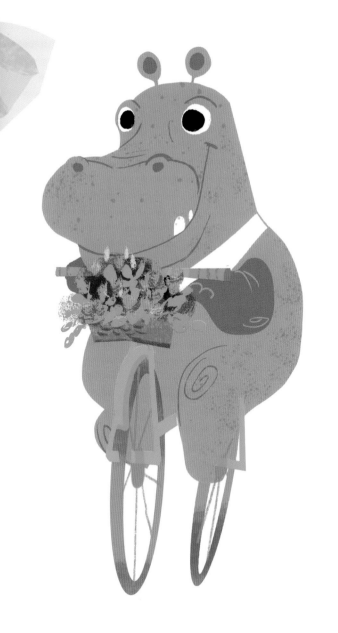

LIGHTER FARE

Sometimes I'm just in the mood for something lighter. I love to draw pretty girls, forests, and flowers, but given that I work in animation, I've always been fond of charming brightly colored characters too. These guys were for a series of little postcards I made for my friends and family. I like the variety of expression and being able to really push the shapes here.

Creating a series like this helps me to think about not just one object standing alone but a series of things that will keep my viewer interested. It's something that we don't think about much when creating art for work, but when you're doing work for a gallery, it's helpful to create a sense of flow!

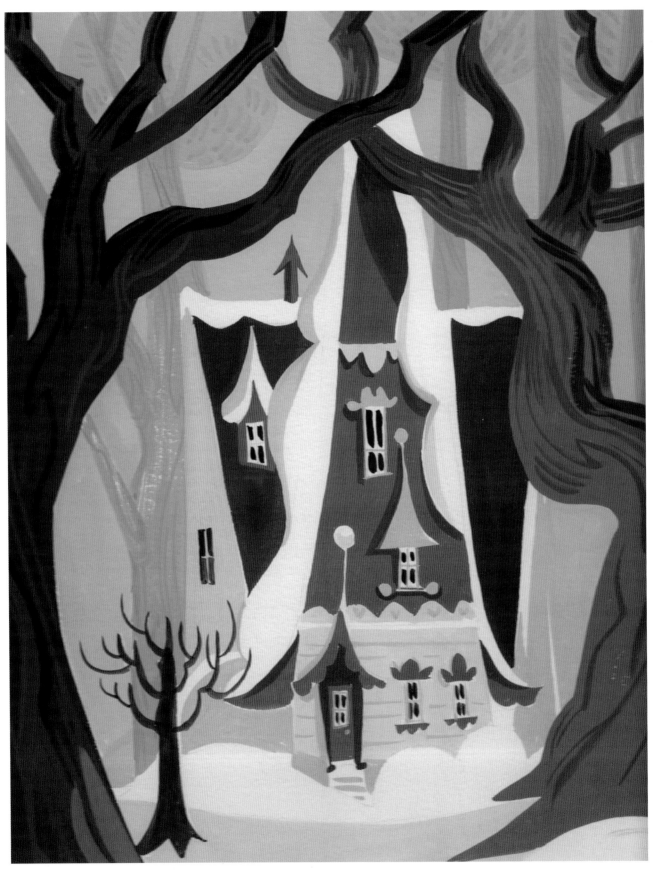

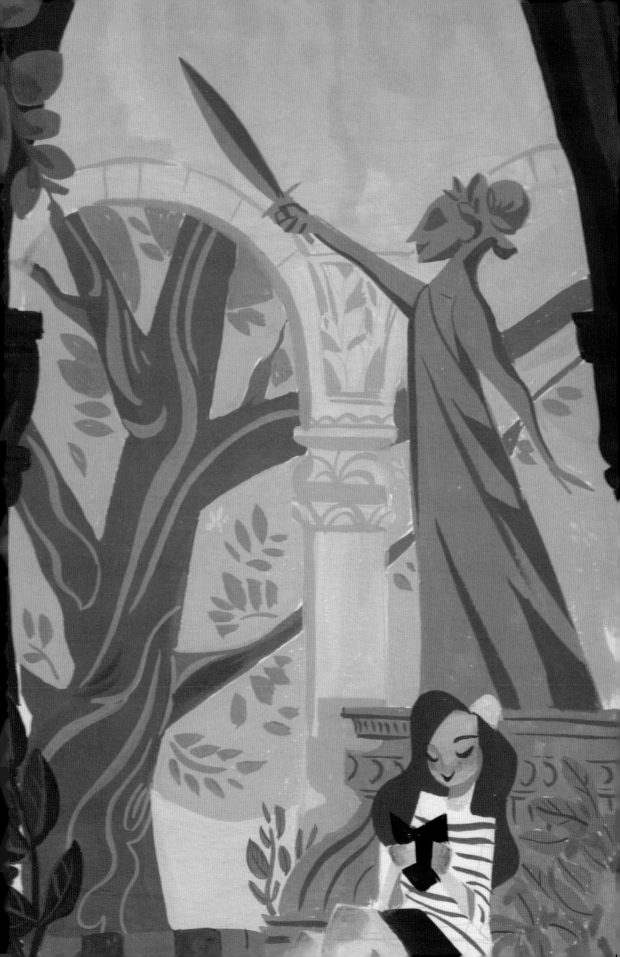

Lorelay Bové

Mingjue Helen Chen

Claire Keane

Lorelay Bové was born in Spain and raised in the Principality of Andorra between France and Spain. She graduated from CalArts in 2007 while completing an internship at Pixar Animation Studios in Emeryville. Lorelay then began her career as a trainee at Walt Disney Animation Studios in the visual-development department. In addition to working on *The Princess and the Frog, Wreck-It Ralph,* and *Winnie the Pooh,* Lorelay has illustrated the *Toy Story* picture book, the Monsters University Fearbook, and Golden books for both *The Princess and the Frog* and *Wreck-It Ralph.*

Mingjue Helen Chen graduated from the Academy of Art University in 2010 and is currently a visual-development artist at Walt Disney Animation Studios. Her work has contributed to films such as *Frankenweenie, Paperman, Wreck-It Ralph,* and many others.

Claire Keane is an illustrator and visual-development artist who worked for many years at Walt Disney Animation Studios. She studied at the Ecole Superieure D'Arts Graphiques in Paris, where she met her husband and part-time collaborator, Vincent Rogozyk. Together they live in Venice, California, with their children, Matisse and Roman. Claire is the daughter of legendary animator Glen Keane, and granddaughter of Bil Keane, creator of the comic strip *The Family Circus.* She has designed on movies such as *Tangled, Enchanted,* and *Frozen.*

www.lorelaybove.com

jigokuen.tumblr.com

www.claireonacloud.com

Lisa Keene

Brittney Lee

Victoria Ying

Lisa Keene was educated at USC and Art Center College of Design and is a voting member of the Academy of Motion Picture Arts and Sciences. For over 25 years, she has contributed as a visual-development artist, art director, and background supervisor for such films as *Beauty and the Beast, The Lion King, The Hunchback of Notre Dame, Enchanted, Tangled,* and *Frozen.* In addition, Lisa has quietly developed a collection of paintings celebrating and capturing the spirit and origin of dogs. Lisa brings an observant eye to the heart, soul, play, heartbreak, joy, pleasure, and profundity of man's best friend.

Brittney Lee is a visual-development artist at Walt Disney Animation Studios. A graduate of Rochester Institute of Technology, she knew that she would pursue a career in animation from the moment she saw *The Little Mermaid* at age 6. Brittney currently lives in Los Angeles with her husband and their small orange cat. Her handiwork can be found in *Frozen* and *Wreck-It Ralph* as well as the Disney short films *Paperman* and *Get A Horse!*

Victoria Ying graduated from Art Center College of Design with a major in illustration and a minor in entertainment design. She has done work for children's books and feature animation. She works as a visual-development artist at Walt Disney Animation Studios, where she just completed work on *Tangled, Paperman, Frozen,* and *Wreck-It Ralph.* She is currently busy working on not-yet-announced projects.

www.lisakeene.com

britsketch.blogspot.com

www.eca-la.com

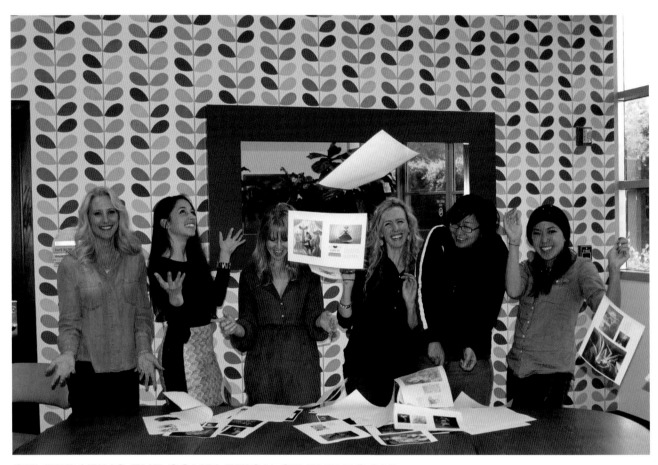

CELEBRATING THE COMPLETION OF THE BOOK!
January 14, 2014

THANK YOU!

It's always a challenge to put together a book. A lot of sweat, toil, and time went into these pages. We hope it shows.

This book is as much a group effort as it is an individual one. We couldn't have gotten to where we are without the support of our families, our friends, and our co-workers. We are thankful to have their support.

We also are indebted to our many Kickstarter backers. Without you, this book would not be in your hands. Thank you for your generous support and enthusiasm for our project.

We would like to extend a special thanks to the Walt Disney Animation Studios for providing a creative home for all of us as well as helping us bring this project to fruition. We'd also like to thank Jonathan Ying for editing the manuscript and Mike Yamada for the hours toiling away in InDesign.

Finally, we'd like to thank you, the reader. We hope you enjoyed your journey through our book and found yourself inspired.

LORELAY BOVÉ

MINGJUE HELEN CHEN

CLAIRE KEANE

LISA KEENE

70 – 71
Matilda, oil on linen, 18 x 23 in.

72 – 73
Niki, oil on linen, 15 x 12 in.

74 – 75
(left) *Stubaluna*, oil on linen, 13 x 18 in.
(right) *Stubs*, gouache on watercolor paper,
5 x 7 in.

76 – 77
(left) *Lulu Peeking*, oil on linen, 10 x 14 in.
(middle) *Lulu Sketch*, oil on linen, 11 x 14 in.
(right) *Lulu*, oil on linen, 11 x 14 in.

78 – 79
(left) *Choppers*, oil on linen, 14 x 18 in.
(right) *Precious*, oil on linen, 14 x 18 in.

80 – 81
Montabello, oil on linen, 32 x 27 in.

82 – 83
(left) *Pongo Ranch Foreman*, oil on linen,
15 x 24 in.
(second to the left)
Pongo Ranch Foreman: Lay In 1, oil on linen,
15 x 24 in.
(second to the right)
Pongo Ranch Foreman: Lay In 2, oil on linen,
15 x 24 in.
(right) *Pongo Ranch Foreman: Lay In 3*,
oil on linen, 15 x 24 in.

84 – 85
Sheriff's Chair, oil on linen, 18 x 22 in.
Topper's Tummy, graphite and oil on linen,
13 x 19 in.

86 – 87
(left) *Ellie: Lay In*, oil on linen, 18 x 27 in.
(right) *Ellie*, oil on linen, 18 x 27 in.

88 – 89
(left) *Buddy*, digital sketch
(right) *Figaro*, oil on linen, 9.5 x 10 in.
(inspired by Disney's Pinocchio)

129
Photo Credit: Franklin Teng

BRITTNEY LEE

90 – 91
Anchors Away, cut paper and gouache,
11 x 14 in.

92 – 93
(left) *Whirlpool*, cut paper and gouache,
8.5 x 11 in.
(center) *Wedding Bird 1*, digital, 5 x 7 in.
(right) *Wedding Bird 2*, digital, 5 x 7 in.

94 – 95
(top) *Drink Like a Fish*,
cut paper and gouache, 16.5 x 31.5 in.
(bottom) *Aloha! Bienvenue! Welcome!*,
cut paper and gouache, 5.5 x 23.5 in.
(right) *Paris*, cut paper and gouache, 4 x 6 in.

96 – 97
(left) *El Mariachi*, cut paper and gouache,
8.5 x 11 in.
(right) *Sunbathing*, digital, 13 x 19 in.

98 – 99
(left) *The Muse of Literature*,
cut paper and gouache, 4 x 12 in.
(center) *The Muse of Science*,
cut paper and gouache, 4 x 12 in.
(right) *The Muse of the Arts*,
cut paper and gouache, 4 x 12 in.

100 – 101
(left) *Coco*, cut paper and gouache, 10 x 14 in.
(top) *Calendar Girl*,
maple plywood and acrylic, digital, 6 x 9 in.
(bottom right) *Calendar Girl Detail*, digital,
7 x 6 in.

102 – 103
Queen of Hearts, cut paper and gouache,
12 x 16 in.
Queen of Spades, cut paper and gouache,
12 x 16 in.

104 – 105
Queen of Diamonds, cut paper and gouache,
12 x 16 in.
Queen of Clubs, cut paper and gouache,
12 x 16 in.

106 – 107
(left) *Morning Fog*, digital, 8 x 18 in.
(center) *Lagoon Love*, digital, 8 x 18 in.
(right) *First Sight*, digital, 8 x 18 in.

108 – 109
(left) *Crane*, cut paper and gouache, 9 x 12 in.
(top) *Sleeping Fox 1*, cut paper and gouache,
5 x 5 in.
(bottom right) *Sleeping Fox 2*,
cut paper and gouache, 5 x 5 in.

VICTORIA YING

110 – 111
Ink Ballet, ink and Prismacolor, 7 x 10 in.

112 – 113
(left) *Green 1*, watercolor, 5 x 7 in.
(center left) *Green 2*, watercolor, 5 x 7 in.
Green 3, watercolor, 5 x 7 in.

114 – 115
(left) *Deep Floral Arrangement*, digital
Golden Florals, digital

116 – 117
(top left) *Bridge over Water*, digital
(bottom left) *South American Dreams*, digital
(bottom right) *Mother Nature*, digital
(top right) *Forest Magic*, digital

118 – 119
(left) *Tropical Ink*, ink and digital, 7 x 10 in.
(center) *Nude*, ink and digital, 7 x 10 in.
Nude 2, ink and digital, 7 x 10 in.

120 – 121
(left) *Shahrazad 1*, marker and Ink, 5 x 7 in.
(center) *Shahrazad 2*, marker and ink, 5 x 7 in.
Dark Girl, ink and Prismacolor, 7 x 10 in.

122 – 123
(left) *Warm Watercolor*, watercolor, 18 x 24 in.
Cubist Girls, prismacolor and watercolor,
18 x 24 in.

124 – 125
(left) *Descending, Bond*, digital, 13 x 19 in.

126 – 127
Elephant, Crocodile, Giraffe, Hippo, digital

128 – 129
(left) *Winter House*, gouache, 11 x 14 in.
Gravesite, gouache, 11 x 14 in.

ALSO AVAILABLE FROM

isbn 978-0-9857707-1-6

isbn 978-0-9857707-3-0

isbn 978-0-9857707-0-9

isbn 978-0985770723

Extracurricular Activities | **Website:** www.eca-la.com | **E-mail:** say@eca-la.com

ALSO AVAILABLE FROM

designstudio PRESS

isbn 978-1-933492-80-3

isbn 978-1-933492-70-4

isbn 978-1-933492-88-9

isbn 978-1-933492-95-7

To order additional copies of this book and to view other books we offer, please visit: **www.designstudiopress.com**

For volume purchases and resale inquiries, please email: **info@designstudiopress.com**

To be notified of new releases, special discounts and events, please sign up for the mailing list on our website, join our Facebook fan page, or follow us on Twitter:

 facebook.com/designstudiopress

 twitter.com/DStudioPress

Or you can write to:
Design Studio Press
8577 Higuera Street
Culver City, CA 90232

Telephone: **310.836.3116**
Fax: **310.836.1136**